Amphoto's Guide to

CREATIVE
DIGITAL
PHOTOGRAPHY

Techniques for Mastering
Your Digital SLR Camera

GEORGE SCHAUB

AMPHOTO BOOKS

An imprint of Watson-Guptill Publications
New York

To Grace

First published in 2004 by Amphoto Books
An imprint of Watson-Guptill Publications
A division of VNU Business Media, Inc.
770 Broadway
New York, NY 10003
www.wgpub.com
www.amphotobooks.com

Text and illustrations copyright © 2004 George Schaub

Library of Congress Control Number: 2004110183

ISBN 0-8174-3485-2

Printed in the U.S.A.

1 2 3 4 5 6 7 8 9 10 11 / 09 08 07 06 05 04

Senior Acquisitions Editor: Victoria Craven
Senior Developmental Editor: Stephen Brewer
Designer: Jay Anning, Thumb Print
Senior Production Manager: Ellen Greene
Production Manager: Rebecca Cremonese

Text set in ITC Weidemann

Contents

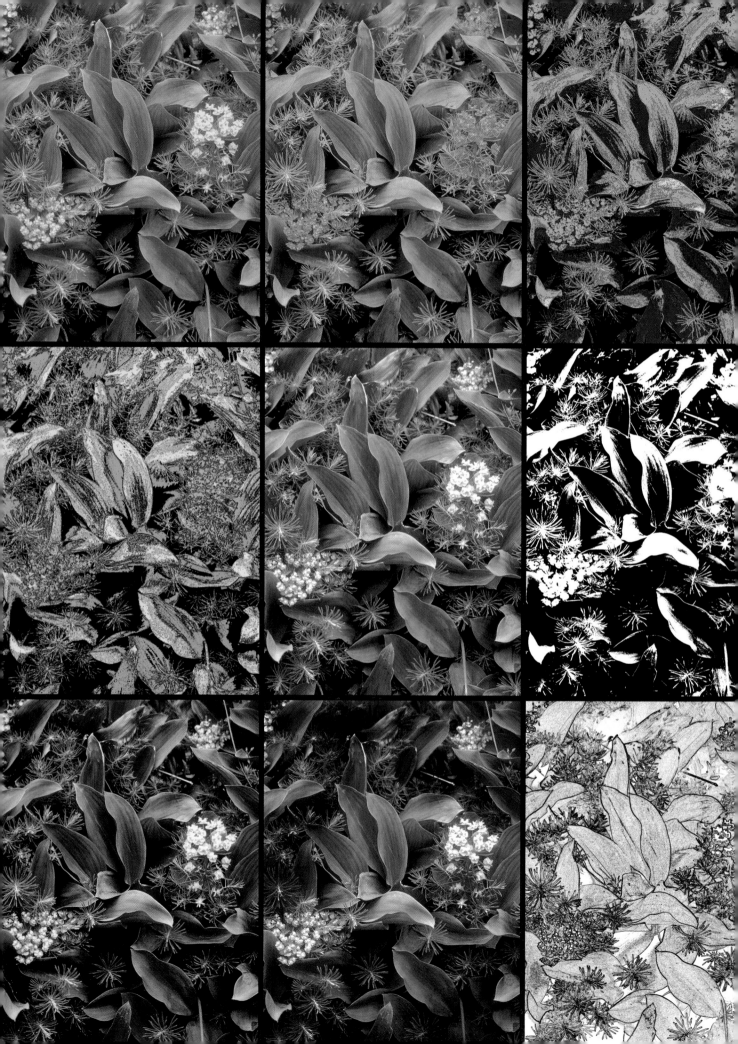

Introduction

Your decision to work with an advanced lens shutter or digital single lens reflex (DSLR) camera has profound implications for the way you make, process, store and print your images. True, both film and digital photography capture light and require processing steps to see that recording as an image. But digital imaging differs in that it begins as an electronic signal generated by light and ends up as binary code that describes color, brightness and tonality. It is in how you deal with those codes to create an image that makes digital so different. Digital imposes, if you will, a different grammar of representation, one that you should learn to be more successful in your work.

The transition from working with film to working with digital creates many new challenges, influencing everything from how you set up the camera prior to making images to what you can do with that image after exposure and processing. Having spent most of my photographic career as a film photographer and darkroom printer I was at first reluctant to become engaged with these challenges, and in fact in the first few years I was convinced that film was and would remain vastly superior to this odd upstart. But as digital sensors improved, as photo-quality printers and razor-sharp scanners became available, and more affordable, I began my study of this new medium in earnest.

As a writer, photographer and editor I have been lucky enough to be able to follow digital from its earliest beginnings and to see how vastly improved the gear and materials have become. My "conversion" to digital came a few short years ago when I realized that digital technology was an extension of all that I had learned as a film photographer and printer. "Going digital" did not force me to throw away my instincts and knowledge but rather brought them to bear in a medium that offered so many more possibilities. I still work with film images I made in the past but use digital to print and share them with others. Today, every aspect of my professional and personal work is bound up with dig-ital imaging. It's brought me more in touch with my photography and personal vision than ever before.

At first, digital cameras can seem familiar. Placed side by side, film and digital cameras often resemble one another; in fact, many digital cameras, and especially digital SLRs, are built inside the frame of a 35mm SLR body. There are also similar buttons, dials and controls. Terms such as shutter speed, aperture, autofocusing and exposure, all quite familiar to the film photographer, make the jump to digital photography. The two mediums diverge in the behavior of the digital sensor, especially with the image record—the digital image file. This is so unlike the film record that it's easy to become confused by familiar terms that mask the need for very different operating procedures.

Digital images require considerably more "housekeeping" than film does. Both types of images must be stored properly, be kept safe from damaging influences and be archived in a way that makes them readily accessible. But you can hold a piece of film up to the light to see the image. Not so with the digital image file. It is "virtual" (mathematical, really) and requires a good deal of computation to be read. It cannot be seen without the aid of a computing device and requires the intercession of yet more machines and mediums to be maintained, and it is always tied to the "grid"—sometimes called the "digital imaging infrastructure."

Quick-paced changes in digital photography render some cameras and devices obsolete in short order. Digital technology can drop image-recording media entirely. This pace of change means that the digital photographer must keep up with changes in the computer industry and be aware how some modes of recording and reading systems will change. This is, in a sense, the dirty little secret of digital imaging. As you get more involved you'll see how important it is to know about the changes that occur with copying and backup, as well as with recording and playback systems and formats.

Digital imaging allows you to become very creative with your images, and the possibilities are endless. Digital controls make it easy to change colors with Hue/Saturation controls, alter contrast with Levels and Brightness/Contrast controls, change the colors with a Solarization Filter, change the photo to black and white with Desaturate control, and add a pen and ink effect with Threshold adjustment and a line-drawing effect with a Fine Edges Filter. The possibilities are limited only by your imagination.

Keep in mind, too, that this medium is in its infancy—things will continue to change. But the reason for going down the digital road is the incredible potential for creative expression it affords; this is the reward for the sometimes-daunting learning curve it imposes.

Digital can become an all-encompassing form of photographic activity. It can involve you in every step of creating your images. It allows you to do things with your pictures you never thought possible. Consider, for instance, that digital photography:

• Has created a revolution in the way photos are retouched and restored and with it you can enliven faded dyes, restore density and repair ripped and crumbled photographs.

• Opens the doors to creative print work that were previously available only to those with years of darkroom and printing experience.

• Removes the necessity of carrying many types of film in your camera bag that could handle different types of lighting levels and sources of illumination.

• Allows you to make corrections with ease and carry the work forward to incredible heights of interpretation and refinement.

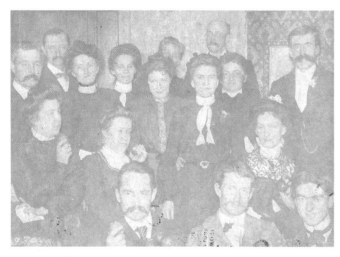

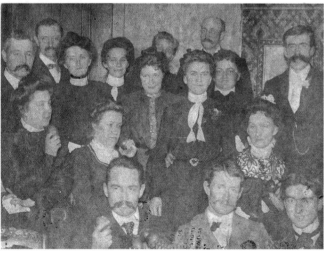

Digital technology allows you to preserve and protect vintage photos, such as this Victorian-era party shot that I scanned then enhanced with editing software.

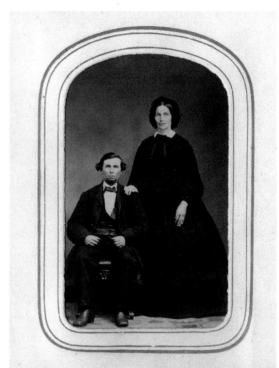

Using a digital camera, I photographed this 1880s studio portrait out of an old album and used imaging software to retouch it.

• Eliminates the problem caused by the often-fickle quality of film processing labs, where the lack of quality control in one chemical bath could ruin a day's work. And digital image media will not become fogged or light streaked by inspection equipment at airports and other secure areas that have become, unfortunately, an increasing presence in our lives.

The "digital darkroom" is where many of the most creative aspects of digital photography come into play. (This misnomer is a clear example of how film photography becomes a reference point when dealing with digital.) The development of incredible image processing and manipulation programs, as well as the wide variety of papers and inks we can use to make prints, has spawned a revolution in printmaking and image creation.

An important part of creativity is the ability to make "mistakes," to try something new with an image without wasting too much time and material. This is one of the strong points of working with digital images—the very nature of the medium encourages experimentation and always seems to offer something new to learn. True, this trial and error approach can be explored in the chemical darkroom as well. But when you work with image-editing programs you can try so many variations on an image that the danger is having too many choices rather than too few. Those who have been enticed by alternative photographic processes—including cyanotype, Van Dyke brown and even photo silk screening—will feel a sense of liberation when working with image-editing programs. This is a wide-open field where your creative impulses can be given full rein and, to my mind, where everyone can define their own unique vision with newfound freedom.

The purpose of this book is to take up photography where film ends and digital begins. I do and must reference film photography as the legacy of this endeavor and as the basis for future understanding, but I also recognize that digital is in many ways a new game. The primary nature of what we deem "photographic" has not really changed. What has changed is the ability to become more expressive, freer and more experimental in nearly every aspect of our art and craft.

As someone who is preparing to make the step into creative digital photography, you are a pioneer of the next phase of the photographic art and craft. You will define just how photography will change and what images can express as this century unfolds. In terms of the history of photography, we are now in a time that is as profound in its changes as when roll film replaced the wet plate process. It's a great time to be involved!

In the end I came to realize that photography is still all about the image and what I want to express. Digital imaging is a tool that can serve the creative eye. It is the next stage in the evolution of this art and craft. It opens up new doors of creativity. And it allows us to better share our vision with the world. All of that and more make digital imaging a very exciting form of visual expression, one that will continue to offer great rewards and challenges as it continues to evolve.

Printing old glass plate images is very difficult and time consuming in a traditional photographic darkroom, but I was able to scan this one on an inexpensive flatbed scanner then reversed, touched up and printed the photo using imaging software and an inkjet printer.

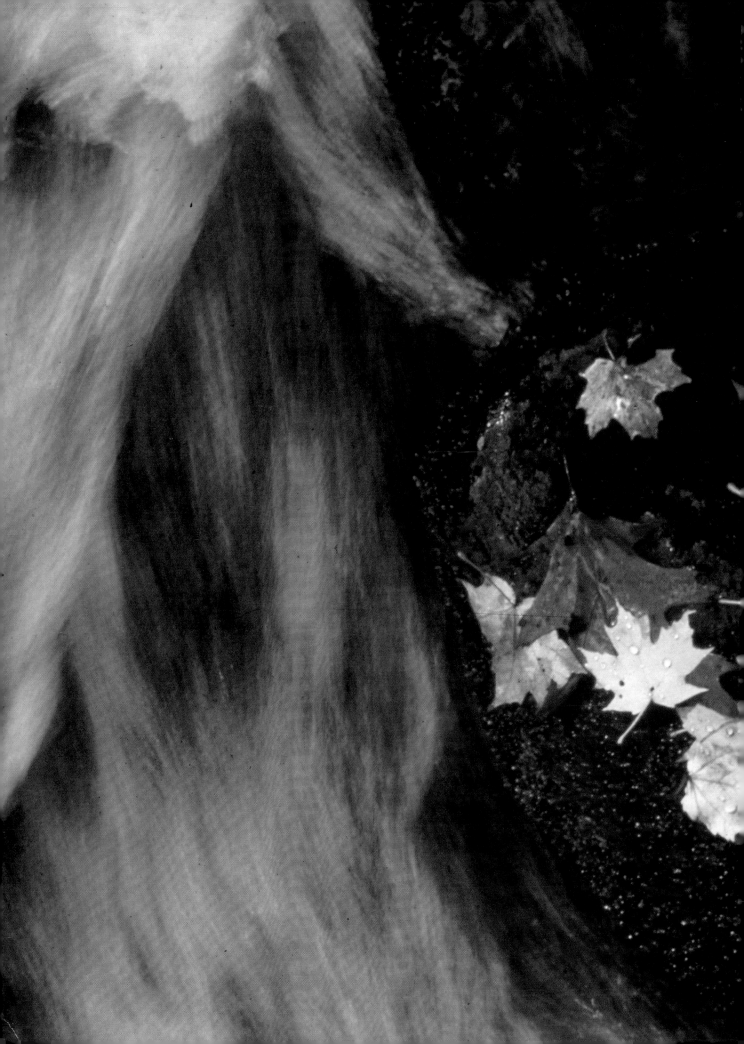

Basics of Digital Photography

PHOTOGRAPHY IS A COMBINATION OF ART AND SCIENCE; it is a medium in which creativity is informed by craft. Exposure, tonality, density, color balance, and contrast are the tools of this craft, and they are important aspects of any photographic approach to seeing and creating images. A grasp of these concepts forms a basis for the successful recording of the subject and scene in the way you desire and, in general, makes you a better photographer. So, before we begin to explore the tools and techniques of digital photography, let's lay some foundations that we will be coming back to many times throughout this book. As we'll see, although the concepts are common to both film and digital photography, their practical application in each medium can be quite different.

The way you balance aperture and shutter speed has a profound effect on your visual expressions; here, a slow shutter speed creates flowing motion in a stream.

Exposure

Exposure refers to the changes that light causes when it strikes a photosensitive material. The two components of exposure are time (or duration of exposure) and intensity (the volume of light that strikes the material). In both film and digital systems the exposure is composed of two factors: the shutter speed and the aperture, the size of the opening in the lens through which the light travels. You can think of exposure in terms of turning on a faucet and letting water flow through a pipe. The longer the tap is open, the greater the amount of water that will flow through. Likewise, the larger the pipe, the greater the volume of water that can run through it in a given period of time.

Exposure is calibrated with a system of stops, or the modern equivalent, EV (Exposure Value). If the total amount of light doubles or halves there is a change of one stop, or one Exposure Value. A 1 stop or 1 EV change can be made by halving or doubling the shutter speed (for example, changing from 1/15 to 1/30 second, or from 1/30 to 1/15 second) or by opening or closing the lens diameter by one f-stop (for example, by going from f/11 to f/8 or from f/8 to f/11).

It's possible to expose with the same amount of light and alter image effects. If we use a faster shutter speed we can freeze motion; if we use a narrower lens opening we can change Depth of Field. As long as we maintain a balance between the two (change the shutter speed in inverse proportion to how we change the aperture) we maintain the same overall exposure. This setup is called Equivalent Exposure and is the basis for many creative techniques used in photography.

The system known as Equivalent Exposure allows you to create different image effects using the same amount of light in the scene. With a narrow aperture, the flower in this scene is sharp while the background remains clear; with a wider aperture, the background loses its sharpness.

Tonality

Tonality is our visual reference of form, color and light. It is the pattern of shade and color that shapes a photograph and creates a sense of reality. In essence, tonality is what makes a photograph a valid and true representation of a form and its tactile characteristics. It allows us to touch a subject or scene with our eyes. A shading of grays and a range of color informs us about the subject and its texture, reflectivity, shape and relationship to other subjects around it.

In a black-and-white photograph of a sphere lit by a single light, tonal range allows us to understand the intensity of the light source, the roundedness of the sphere and the way shadows create forms. We can even grasp the texture of that form by observing the way light reflects or is absorbed on its surface. If the sphere is red, tonality imparts a range of colors, from pale through deeper reds, depending on where the light is striking the sphere, as well as a range of texture, depending on the surface of the sphere.

We can, of course, manipulate tonality to our own taste in order to add emphasis to certain subjects or overall mood to a scene. Tonality is a prime consideration in both film and digital photography. Only when digital images began to offer a tonal range equal to film did photographers begin to take the technology seriously.

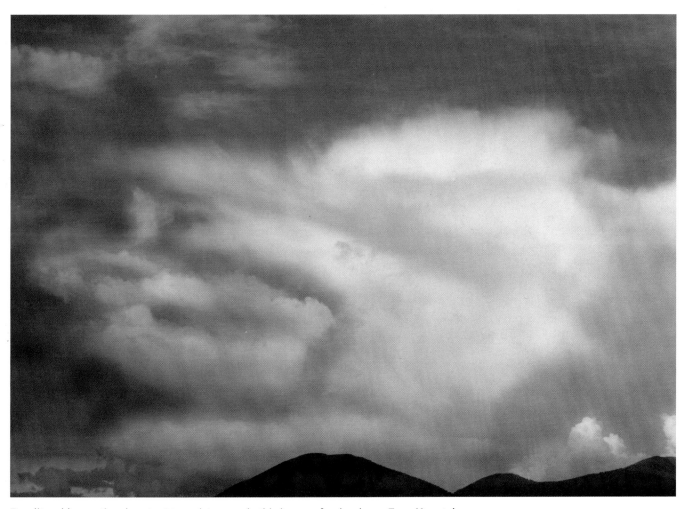

Tonality adds emotional content to a picture, as in this image of a cloud over Taos Mountain.

This photo of a flea market stall exhibits a full tonal range, from deep shadow to texture in the highlights.

Get the color as true as possible when you make the exposure, then create interpretations later. This way you have all the values at your disposal and you won't have to spend your creative time "fixing" off-color or poorly exposed images. I could reproduce the color range of the dress of these Native American dancers with such vibrancy because I chose exposure and color settings that did not interfere with their reproduction. No tonal values are lost in the exposure of leaves (opposite, top), allowing for intensification of the visual display without sacrificing the dazzling light. An overcast sky (opposite, bottom) creates a perfect lighting condition for brilliant color. I took care not to underexpose the scene, so none of the color potential was lost.

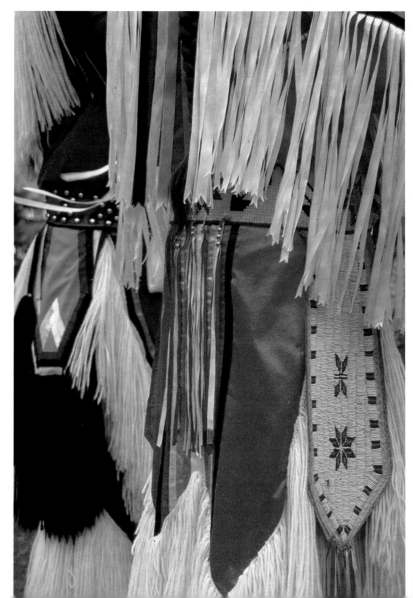

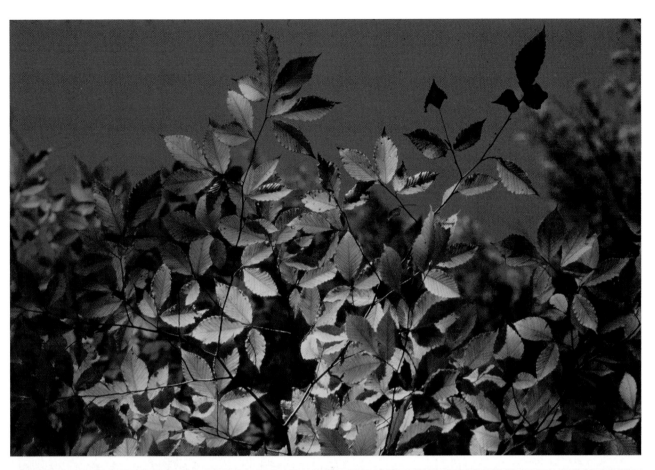

Density/Code

Density is the record of light exposed on film (there is no such thing as "density" in the electronic image file; we'll get to that a little later). The color and brightness of the light is "trapped" within film's various recording layers.

Color film is actually a sandwich of color and densities that forms a cohesive color image to represent the original color and brightness of the scene. When light strikes color film it causes a change in the metallic silver salts that reside within the various color-recording layers. This change occurs in direct proportion to the amount of light that strikes the film. The latent image is then developed in chemical baths that convert the change to various densities of silver deposit, which is replaced with dyes, again in proportion to the amount of light that initially struck the film.

The density of black-and-white films is determined by an actual metallic silver deposit; in chromogenic black-and-white film the density is created by monochrome dyes that replace the silver during processing. In processed negative films (color and black-and-white print film) the density is the opposite of the brightness in the scene—brighter areas in the scene have more density and are darker on the negative, while darker areas in the scene show up as light areas on the negative. When a print is made these densities are reversed to mirror the brightness values of the original scene. In slide film, which begins as a negative, the reversal is made during the filming process, thus we get a positive image on film.

Proper exposure also has a profound effect on the ability of an electronic image file to reproduce the color and brightness of the original scene. The difference is that there is no metallic photosensitive material in a digital sensor; rather, it is composed of photo sites (called pixels) that respond to photons (light energy) by creating an electrical charge. The variation in charge becomes the basis for codes that define the lights and darks of the image.

Light "informs" a subject with a sense of time and place and defines figure and form with the play of highlight and shadow. The way the light travels and the overall color cast tell us this photograph was made as the sun was setting and also the direction from which the light comes.

Color is recorded in digital sensors in one of two ways. In most digital camera systems a checkerboard of color filters is laid over a grayscale sensor. These filters sort the colors on the chip, which are then reintegrated to form a color image during digital image processing. Another type of color system layers the color-capturing layers much like film does but also processes the color after the image is exposed. In both instances these signals are integrated to form codes that are the "addresses" that indicate the color and brightness value of each pixel.

All digital images are products of electronic signals subject to high levels of computation. The "density," or level of brightness of a digital image and its color, are virtual codes and are not composed of dye or metal. But the computation and subsequent translation of the image codes emulate the density and color of a film image. You can think of a digital image as a vast array of binary sets that define color and brightness. Each pixel is part of a mosaic that when combined forms an image.

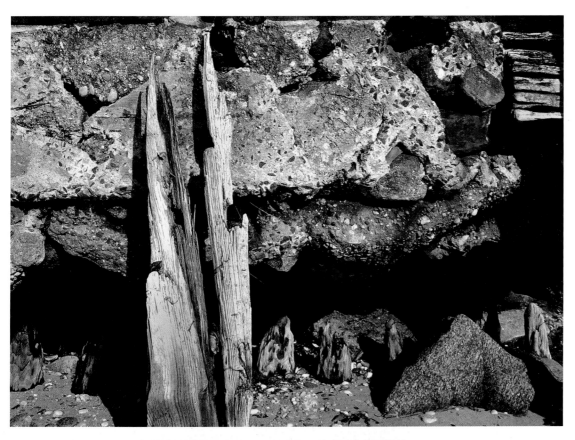

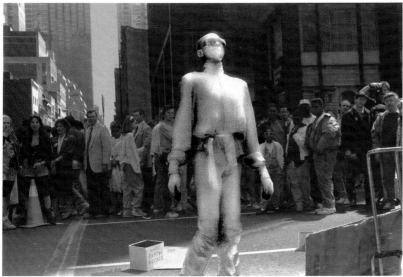

Light helps create a sense of spatial relationship between these rocks and worn pilings and sets up an emotional connection between a street performer bathed in bright light and the crowd moving through the open shadows.

Color Balance

Color balance refers to the way a subject changes depending on the light source under which it is photographed. When color is in "balance" we see the subject as we remember it—a banana records as yellow, a white shirt as white. If the banana records as red and if a white shirt records as yellow, we say that the color rendition is out of balance and it's necessary to make some corrective measures to make up for the difference between the way our eyes see color and how film or a digital imaging sensor "sees" color.

Films are manufactured with a certain color balance, which means they will record true color under certain lighting conditions. "Daylight" color balance (about 5500 degrees Kelvin) is the most common. But if that film is exposed under other lighting conditions the color will not be true. For example, if a daylight-balanced film is exposed in a room lit by incandescent bulbs the image will record with an amber cast. This occurs because the light source is deficient in blue. Our eyes do not see this deficiency, as we adapt to the light source, but the film "expects" the blue to be there.

Films may have a certain color bias built in. This becomes obvious when working with slide films, where overall color can range from "cool" (slight blue bias) to neutral (little bias) to "warm" (slight yellow bias.) In addition, films are made to yield more or less color saturation, and range from slight to sometimes heavy-handed color

richness. Color print film can also range in similar fashion (but most color variation probably occurs in the labs that make the prints).

Some classes of films have tungsten balance (either 3400 or 3200K) that can be used under artificial continuous light. To correct the color in an image most photographers use color-balancing filters over their lenses, make adjustments when printing the image or use a color temperature meter that recommends color-correcting filters (this is the most accurate method of getting true color under a variety of light sources).

Digital cameras and computer imaging techniques eliminate the need to use filters or change film to achieve proper color balance. Instead, digital photography incorporates a processing step known as White Balance that is either programmed into the on-board image processor or into the computer software that processes the image. The camera will automatically adjust to achieve certain White Balance settings, of which there are usually five or six available.

Custom White Balance controls allow the photographer to be more precise and to set the color balance for a very specific light source. (Using custom White Balance controls is the equivalent of using a color temperature meter and adding color-correcting filters accordingly.) In addition, color moods can be enhanced by using White Balance as a color enhancer and to add a touch of warmth (using

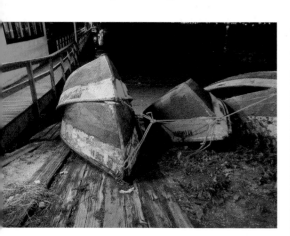

The boats on the dock at night are lit by fluorescent light, one of the most unattractive light sources for photography. Shot in Daylight mode a greenish tinge comes through, but setting fluorescent White Balance on the camera yields a more pleasant, truer color.

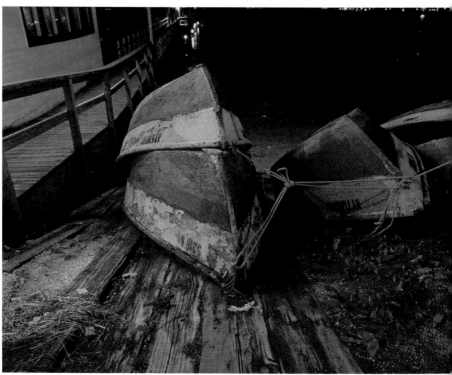

"cloudy" White Balance) or cool blue (using tungsten White Balance) to the image. You can also program the digital camera or use software to modify color saturation. This modification need not be "global" and can be selec-tively applied to each color as desired. In effect, digital photography eliminates the need to record color using spe-cial filters or film and makes it possible to achieve the color balance you want through computer manipulation.

Test your different White Balance settings to see how each affects color under various lighting conditions; a photo shot with White Balance set at Auto works well (left), but not when White Balance is set for Incandescent light (right).

You can use Hue/Saturation controls in editing software to zap up specific colors, such as this red, for extra richness.

Contrast

Contrast is the way in which the scale of light to dark values in a scene are recorded and rendered. Our job as photographers is to render as much of the light to dark values (the available tonal range) in a scene as possible.

Both film and digital systems have a certain range of contrast they can record, and this range (a spread of EVs) determines how we can record detail in shadows and texture in the highlights. Nothing looks worse than a poor rendition of contrast. Harsh sky, muddy color and large areas of blocked-up darkness get in the way of our appreciation of an image and subject. True, when we print or process a film or digital image, we can choose to alter the contrast range as our interpretation of it requires. But recording as full a range as we can gives us more creative freedom later, and restricting the contrast range limits our possibilities.

The range of contrast in film is determined by the inherent nature of the film itself, modified by exposure and how the film is developed. Given good exposure and processing procedures, most films will yield a very good range of values under most lighting conditions. Careful metering and controlled processing can even enhance that range.

If you are an experienced film photographer you probably have followed one of these maxims: "Expose for the shadows and print for the highlights" or "Overexpose and underdevelop." You can forget about these guidelines when using a digital camera. Digital sensors have a certain contrast range in which they can faithfully record bright and dark values within a scene. The way to control and enhance contrast differs, however, because contrast can be varied somewhat by in-camera processing and considerably more in post processing in the computer. You can also use certain recording file formats—mainly Raw—to expand the contrast range potential (more on this in Chapter Four). Many digital cameras are equipped with a Histogram display, a graphic representation of the range of brightness values within the scene. This is an invaluable aid in correcting exposure and metering technique in the field.

All this is not to say that digital imaging provides a magic bullet for solving one of the greatest challenges to photographers—that of contrast control. High contrast scenes pose problems in both mediums, though digital solutions make them easier to address.

Bright-white sand behind this desert plant caused the metering system to read the white as middle gray, but it was easy to adjust the contrast using the Levels control in the editing program.

Proper exposure techniques help record a full range of highlight and shadow to show texture in the snow and open detail in the shadow of the barn.

Brightness/Contrast controls in the editing software make it easy to create variations of contrast renditions of this scene.

How Digital Photography Works

Both film and digital sensors are receptors that aim to replicate the blink of a human eye. They gather light's energy and coalesce the stimulus into a coherent image, filled with continuous tone and color. The sensors are aided in this task by the lens, which focuses the light at or near a point on the plane of the receptor, and the shutter and lens diaphragm, which control the duration and volume of light that is the exposure. In this way, both film and digital photography follow the basic laws of photographic physics.

The digital sensor is a complex microchip that is composed of photo sites, electrical receptors that create a charge when they are exposed to light. After exposure this charge is transferred to a microprocessor that integrates the resultant signal and converts it to binary codes. Each photo site becomes the source of an address that identifies color and brightness. This image-forming system allows us to alter and change the digital image in very discrete and amazing ways and we can emulate any film type and color balance with ease.

At first glance a digital camera resembles a 35mm SLR and in fact performs many of the same functions in similar ways. But the way you capture an image with digital, and what you do before and after you press the shutter, differs a lot from film, and digital photography opens the door to many more creative paths for your pictures.

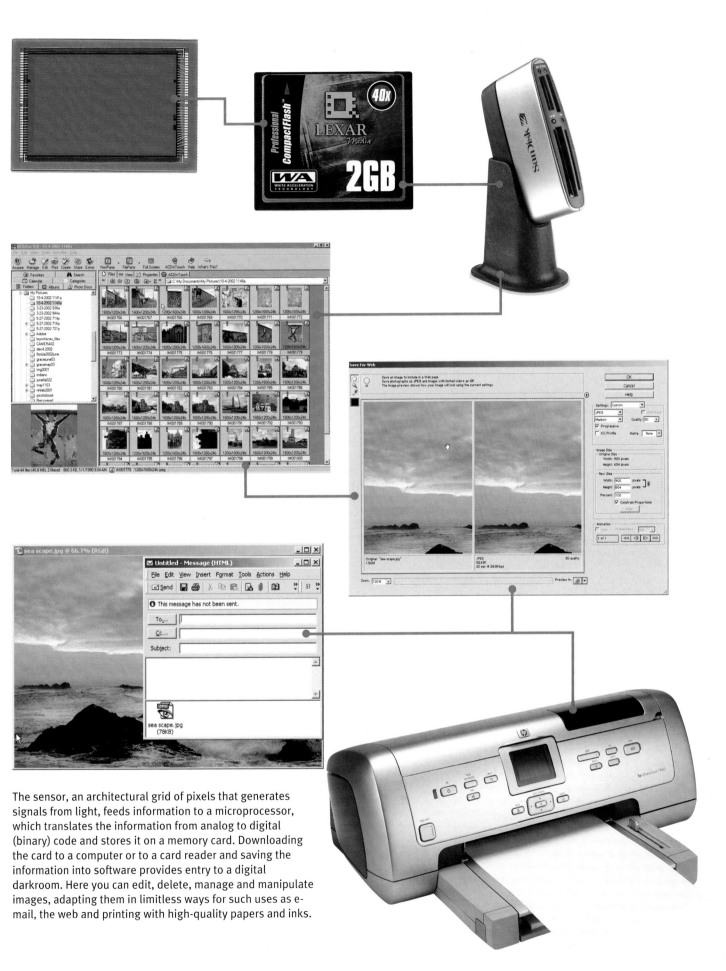

The sensor, an architectural grid of pixels that generates signals from light, feeds information to a microprocessor, which translates the information from analog to digital (binary) code and stores it on a memory card. Downloading the card to a computer or to a card reader and saving the information into software provides entry to a digital darkroom. Here you can edit, delete, manage and manipulate images, adapting them in limitless ways for such uses as e-mail, the web and printing with high-quality papers and inks.

Understanding the Differences Between Film and Digital

WORKING WITH A DIGITAL CAMERA IS AKIN TO writing with a word processor, while shooting with film is more like using a typewriter. In this chapter we'll come to understand just how true this analogy is as we explore some of the aspects of photography that have changed because of the arrival of digital imaging. This difference is profound and creates different paths for exposing, processing and finalizing the image in a print or in a screen picture.

Grains and Pixels

Image Sharpness

ISO (Light Sensitivity)

Durability

Capacity

Image Processing

Seeing the Image

Framing Rates

The creative potential for each photo begins when you release the shutter, because digital allows you to explore many ways to express an image. I converted this photo of a classic car to sepia and polarized it, all easily done with editing software. With a film image, this would have taken hours of darkroom time and required many steps.

Grains and Pixels

A film image is created by microscopic light-sensitive grains that mirror the density and color of the original scene (in color film dyes replace the grains during processing). The relative size or area of the grain determines the light sensitivity of the film, with larger grains being more efficient in their light. Digital images are formed by geometrically shaped pixels (for "picture element") that hold the code for color and light information. Magnify a film image and the grain will become apparent; do the same with a digital image and the geometric shapes of pixels will emerge.

Grain and Noise

We often use similar terms to define the characteristics of film and digital imaging. For example, obtrusive grain in a film image can be thought of as excessive "noise" in a digital image. Noise in a digital image can come from boosting the ISO too far (a gain in sensitivity obtained from applying more current across the sensor field) and from using long exposure times, which allow static and excess charge to deteriorate the image. In essence, as the charge builds up there's more opportunity for artifacts and non-image interference to occur. The high grain in a film image will appear like a mottled and random salt and pepper pattern. Noise in a digital image might appear as random artifacts (discoloration), blurring of colors and a breakdown of tonal borders.

Many digital cameras have what is known as a Noise Reduction function that automatically kicks in when the system detects excess noise in an image, or when a long exposure time is used. This is a microprocessor function that detects and removes noise using a "smoothing" effect to improve the image. With noise-reduction functions, the processing time can be quite long—as long as the image exposure time—and as the image is processing no other images can usually be recorded. Noise Reduction functions are also available in some image-editing programs.

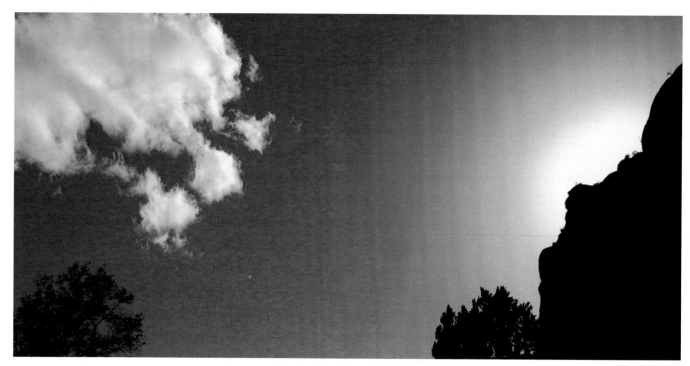

An example of what can go wrong with digital images: Low resolution and aberrations in the lens and recording system cause pixels to break up and banding and crossovers to occur. This "noise" can be reduced somewhat with special image-editing programs.

Image Sharpness

Sharpness in a film image is affected by emulsion thickness and grain size, level of exposure, and development and subsequent enlargement on various contrast-level papers. Digital sharpness can be affected by image resolution and sharpness "processing" applications that are added when the exposure is made or afterwards. Of course, the quality of the lens, the steadiness of the photographer and the shutter speed used affects sharpness in both media.

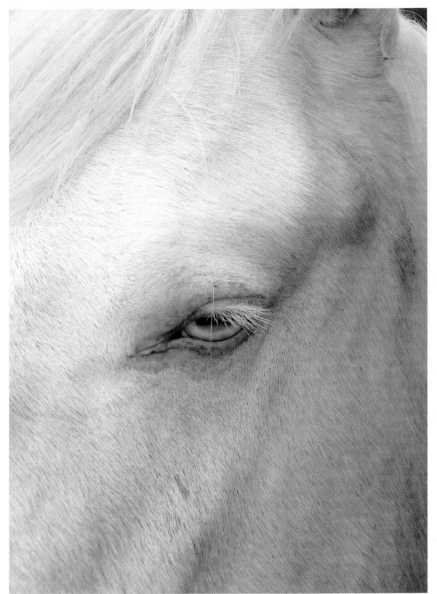

Lenses made especially for digital cameras often deliver an especially fine resolving power, necessary because of the structure of the pixels and the way light is delivered to the sensor. Digital-specific lenses also benefit from being highly corrected, using multicoating and apochromatic elements. In this photo made with a medium-priced digital SLR, you can see the sharpness on every hair of the horse's eyelid, even when the image is enlarged.

ISO (Light Sensitivity)

The concept of light sensitivity, or speed, is similar in both media. Every film has a "native" or manufactured speed that is inherent to the emulsion of the film, and a digital sensor also has a "native" ISO. With film, you can push (elevate) speed by extending the developing time or "pull" (decrease) it by shortening the developing time. With digital cameras, you can apply Gain (electrical charge) across the sensor to achieve higher speed. The available range of ISO selections differs among camera models, and some allow ranges as wide as ISO 100 to ISO 1600. While an entire roll of film must be processed for one speed or another, with digital images a different ISO can be set for each individual frame.

In both film and digital there is a practical limit to how high speeds can be pushed. With digital, keep in mind that noise increases with higher ISOs. The rule for both media is that you should use the lowest ISO you can for the best image quality.

Gaining a stop or more to ISO 400 or 800 allows you to shoot handheld without flash in shadowed city scenes or even in the shade.

One of the main advantages of digital photography is the ability to select an ISO for every frame you shoot. A long-range telephoto shot of this neon sign in Las Vegas is exposed at ISO 800, ensuring picture steadiness.

If light is low and you don't want to use flash, raise the ISO for more sensitivity. On an overcast day in the shade of a tree, there was not enough light to allow me to handhold the camera. So, I raised the ISO to 800.

High speeds come in handy when you can't use flash to make an image, such as this museum interior (right), exposed at ISO 400. But it's always best, if possible, to shoot at the default or "native" speed of the sensor, as with this photo (below) made at ISO 80 in bright daylight.

Durability

Digital copies retain all the characteristics of the original without the "generational loss" usually suffered by film when a film-to-film copy is made. Plus, while film can expire if not used within a certain time, digital technology is durable. Overall, digital sensors and media require far less care than film does. For example:

- Digital chips are not subject to "fogging" or other detrimental factors prior to exposure.

- Digital sensors are not damaged by airport scanners (although it's probably best to avoid having memory cards passed over by hand scanners or other magnetic devices).

- Digital image files will not lose color and density

(although it's a good idea to back them up and copy them occasionally).

In terms of long-term storage, though, keep in mind that the "readers" that translate the digital codes that make up images may become obsolete. As file formats, computer operating systems and programs change, the image might become locked into an older setup that cannot be read. (Think of those now-obsolete 5-inch floppy disks, SyQuest systems, and 8-track tapes.) Also, if CDs and DVDs become scratched or pitted, you will not be able to retrieve your images. The best advice: Check in with the computer world every so often to make sure that the system you use is still current, and always make backups to insure against damage and loss.

Capacity

The capacity of digital memory cards is dependent on two factors—the resolution and compression of the recorded image and the file size capacity of the memory card itself. The resolution and compression determines the size of the recorded file. If, for example, you make a high-resolution, noncompressed image with a 3-megapixel chip, the file size will be about 9 MB (megabytes), so three images can be fit onto a 32 MB card. If the image is photographed with JPEG mode at 1:4 compression at the

same resolution, about 12 images can be stored on the card. If the resolution is changed, or if the resolution *and* compression ratio are changed, then the card will hold proportionally more images.

These numbers might seeming confusing at first, but following the frame countdown on the camera's LED panel will reveal all. See Chapter Three for more on resolution, compression and file formats.

Image Processing

Processing is the way you convert an exposure into visible form. In film, the exposure creates a latent (invisible) image that is made visible through chemical reactions. Film processing involves running the film through a series of chemical baths in a set sequence involving time and temperature controls. With digital technology, processing involves converting the electrical signals to codes via in-camera microcomputers (and/or in-computer programs) that turn those electrical signals into binary code. Image processing is done first in the camera and can be further enhanced when the image is downloaded to an image-editing program. You have the freedom to change a digital image in almost infinite ways—for instance, to correct for exposure deficiencies or to enhance virtually any aspect or character of an image. This ability lends a great deal of creativity to digital imaging.

Digital cameras usually allow you to adjust for sharpness, contrast and even color saturation, as well as White Balance and various exposure overrides. This photo was made with the normal, or default color setting, then with increased contrast and color saturation (plus one on both).

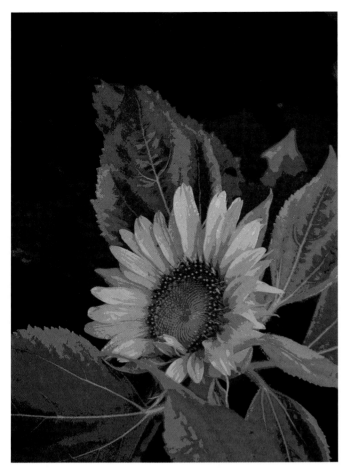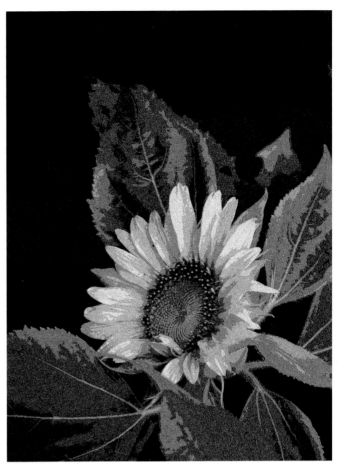

The beauty of digital is that you can shoot in color, then easily convert the image to black and white. I photographed this sunflower in color with the camera set on a Solarize Special Effects mode. I then removed the color but kept the image file in RGB (color) mode and added the brown, sepia effect using a control known as Hue/Saturation in image-editing software.

Processing Variations

Just as photographers who develop their own film and who maintain a strict processing regimen generally obtain better results, so do digital photographers who take the time to dig into their files and correct and enhance their images.

Digital images are in large part "processed" in the camera itself. Any programming you do, such as boosting contrast or color saturation, is applied in the image processor. If you're unhappy with the quality of your digital processing, the problem may be with the processor, which may not be working properly, or with the software. If the problem is with the latter, check the camera company's web site; sometimes companies offer software upgrades that you can download from the Internet.

If you shoot in JPEG or TIFF formats, the camera will automatically process the images. If you want to do your own processing, work with Raw format images. Raw is the digital equivalent of custom film processing, where you add contrast, change color balance and add sharpness to the original image information. If you want to take the time to understand and apply Raw, you'll find that this format provides a fascinating approach to digital imaging. (For more about Raw, see Chapter Three.)

Monochrome Images

All images recorded by digital cameras are color images, composed of three "channels" of red, green and blue (RGB). So, photographers who enjoy black and white might wonder how digital can work for them. In truth, digital is a great way to work in black and white.

If black and white is the desired result, conversions allow the enhancement of one or another of these channels (or a combination manipulation of them all) or the outright elimination of one or another channel.

Photographers, especially those with experience in the craft, often use color filters when exposing black-and-white film to enhance and differentiate color subjects and control and alter contrast. These filters—generally, yellow,

orange and red—block the complimentary color light and pass the same-color light. The classic approach is to mount a yellow filter to deepen the blue in sky (with orange and red providing deeper blue-sky density), a green filter to enhance the forms and patterns of foliage, and a red filter to differentiate between red and green forms or to create an infrared effect with infrared film. The only filter necessary for digital photographers wishing to obtain similar

effects is the red filter for the infrared effect, although some cameras yield this effect more readily than others do.

Not only is it easy to convert color files produced by digital cameras, but image-processing programs make it easy to convert scanned color slide and color negative film into wonderful black and white images. You'll find that it's just as simple to convert the color files you produce with your digital camera to black-and-white images.

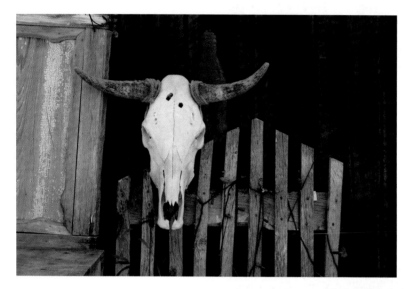

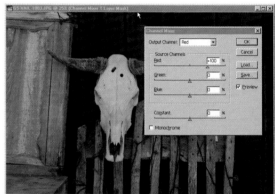

It wasn't necessary to do extensive darkroom work when I decided this color image would look better in black and white: I used a simple tool known as Channel Mixer in Adobe Photoshop and manipulated sliders to get just the tone and contrast desired.

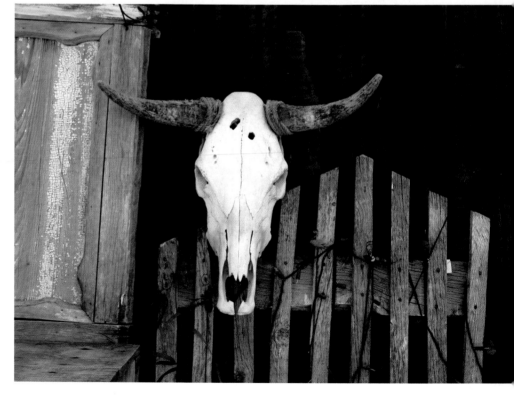

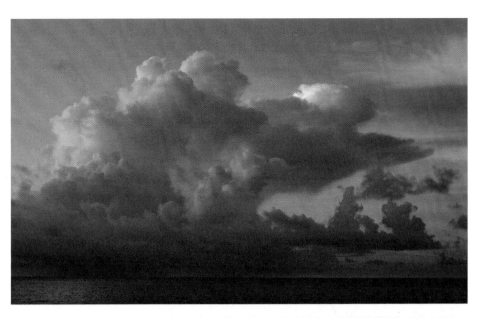

I photographed this cloudscape in color, converted it to black and white in the computer, then used a plug-in from nik multimedia to emulate different color filters.

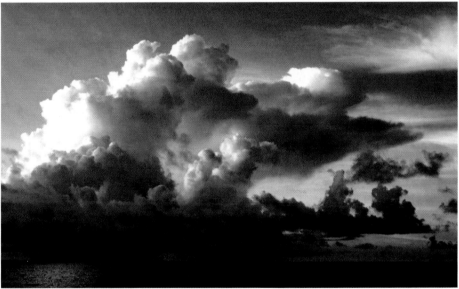

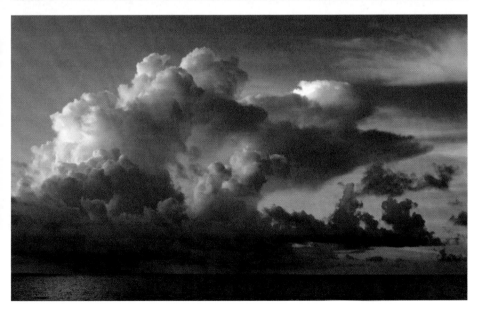

Seeing the Image

To see the results of your work with film requires that the film be developed. In truth, you never *really* know what you've got until all that is done and the film is dried and cut into sleeves or placed in mounts.

One of the key advantages of digital photography is the immediate feedback it provides, so you can judge the quality of pose, point of view, composition, and exposure (contrast and tonal spread) on the spot. Keep in mind, though, that the LCD monitor, with its small size and low resolution, is often a poor indicator of focus and exposure. But if you download the image immediately to a computer, or if the camera is tethered to a computer when the exposure is made, you can make critical judgments right then and there.

On many digital cameras, the playback mode provides some better ways to get a clearer look at images when they appear on the camera's LCD monitor. One is a zoom function that brings up select areas of the image to fill the monitor screen. You can use this, for example, to ensure that all eyes are open in a group shot or to check critical focus on the petal of a flower. The other, and perhaps more useful tool, is the Histogram readout. A Histogram is a visual map of tonal spread and allows you to judge how well you have exposed the image. Some cameras also have overexposure warning functions; with these, areas that have received too much exposure will flash with a user-selectable color to indicate the problem. Keep in mind, though, that any information you get from the LCD is often blocked by poor readability in bright daylight. This is why you might want to use an accessory hood or view the LCD in shade.

Framing Rates

Film allows for high framing rates (the ability to record a number of frames sequentially in a short period of time), with some film cameras shooting as fast as 10 frames per second. Digital cameras, though, do not always offer the same advantage, because many digital cameras can only make an exposure after the image processor has sent the image to the memory card. The processing time will vary according to the speed of the processor and the size of the image file (resolution), and if functions such as Noise Reduction are used, the processing time will increase.

To compensate for this seeming deficiency some advanced digital cameras feature on-board buffers that store the raw image information before processing. This allows higher framing rates than would otherwise be available. The buffer does not hold images per se, but stores the image information that will be processed to become an actual image file. Since the images have to be processed at one point—usually when the buffer is full—digital cameras can offer high framing rates only in a set period of time and with a certain file size capacity. The specs will read, for example, 3 frames per second for ten seconds, or a limit of 30 frames at a high burst rate.

Similarly, some digital cameras offer a "movie" mode that records a series of images in sequence. The movie mode runs for a period of time determined by the capacity of the memory card in the camera and the speed with which it can receive images. Many deliver framing rates equal to those available in camcorders.

Film cameras have a speed advantage when it comes to framing rates and burst, because digital cameras store images like these, made with a digital SLR set at consecutive drive, in a buffer and hold off on image processing until the burst capacity is filled. The microprocessor then accesses the buffer and processes the images, during which time no more images can be exposed. But write-accelerated cards are speeding up this process.

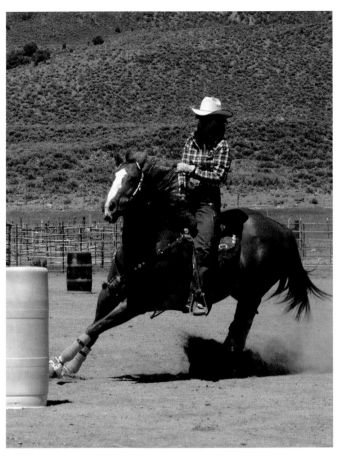
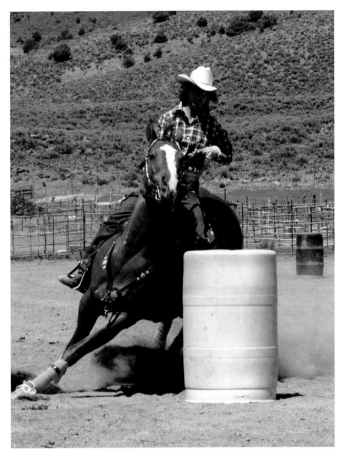
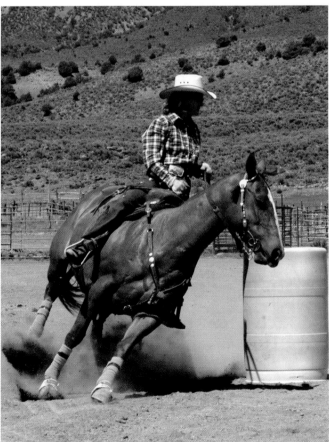
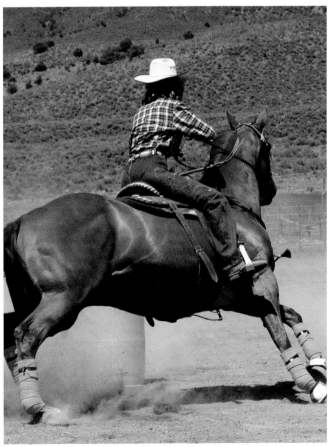

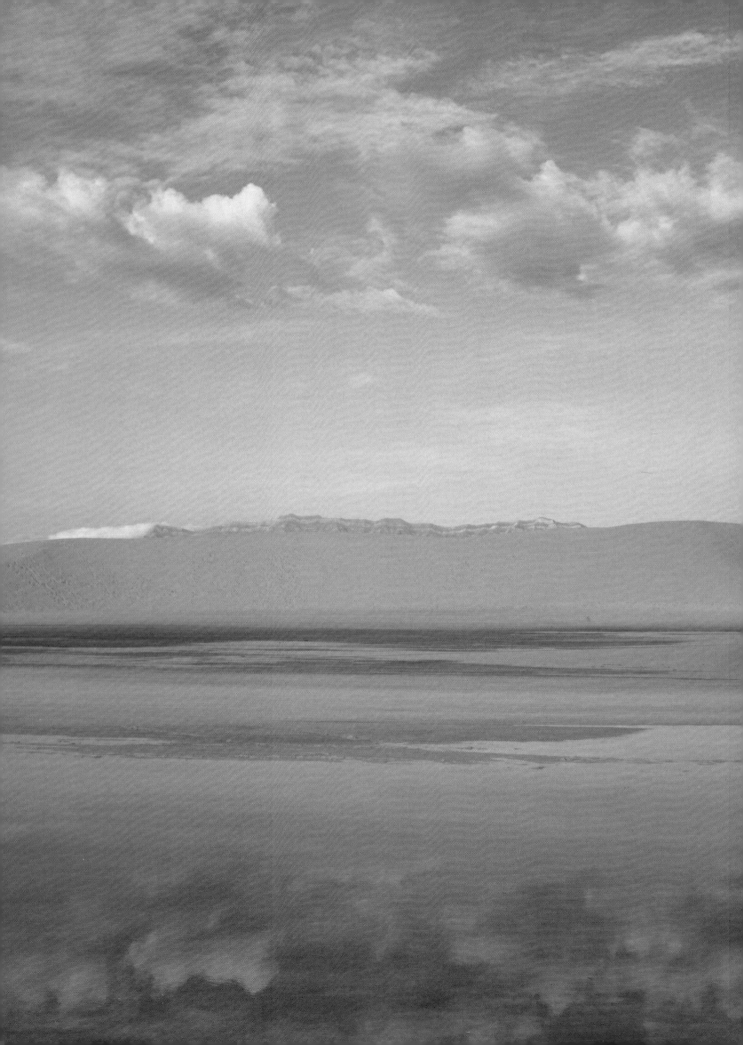

The Electronic Image File

IN THIS CHAPTER WE'LL ADDRESS FILE SIZES, FORMAT, compression and recording modes—all important elements in making digital images. While these terms and their applications might seem complicated at first, some testing and practice will remove any confusion about when to use each for the types of images you want to create. As you gain experience, you'll come to understand why you might choose one size, format or compression ratio over another. There's no one right choice for every image, and the possibilities are endless.

In this image, made from a 13 MB file size, every line and separation between tones is sharp and distinct and colors show a subtle gradation.

The Pixel Puzzle

Digital photography begins with the pixel. Short for "picture element," a pixel is one piece of a large mosaic grid that makes up an image. If you have the opportunity to view the masterly mosaics in a church or art museum, stand back and consider the whole, then slowly walk toward the piece until you are a nose-length away. You'll quickly see how millions of little pieces can form a coherent image. To have the same experience with pixels, bring an image up on your monitor and repeatedly hit the zoom control until the individual pixels come into focus.

Pixels are made up of a code describing the image characteristics that is then translated to form the image. Each pixel has an address, a specific marker as to where it resides in the overall scheme of the other pixels in the

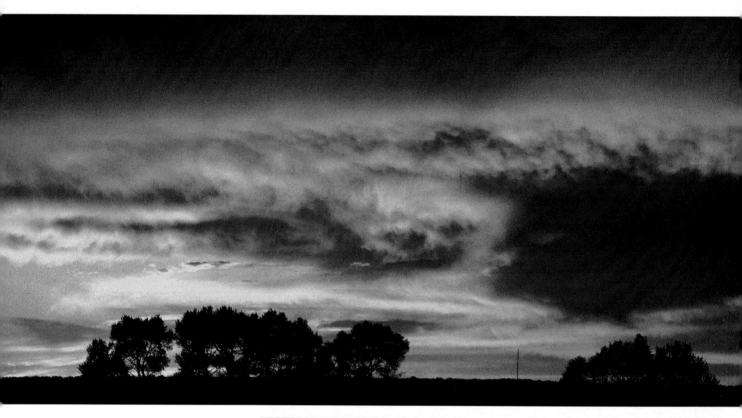

In film, light-sensitive grains of silver halide sit within the color recording layers. If you enlarge film greatly the "echo" of the grain is evident in the color dye record.

image and such attributes as color and brightness. The ability to work with an image on a pixel-by-pixel level, and to alter the address of each pixel, is what makes digital imaging such a powerful visual tool.

For example, say you have a specific color of blue in an image and you want to enhance that blue and make it more vivid. Using a tool known as an Eyedropper, you can "pick up" the address of the pixel and then select that and all other pixels with the same or similar character. You can even define a "range of blueness" to be selected. You can then change the code of all those pixels to exhibit more color saturation, or change that blue to red. You are in essence changing the code, thus the visual appearance, of all those pixels you have selected. All this is done by a microprocessor in the computer, and the speed at which you make these changes is quite amazing.

Extend that control to the entire image and you begin to see how having pixels as the building blocks of the image opens new, creative doors. When you make black-and-white prints in the chemical darkroom, for example, you alter contrast by using contrast grade paper or variable contrast filters under the light source with variable contrast paper. When you work with pixels you can selectively change the degree of contrast of highlights, midtones and shadow areas, all without affecting the other areas. This control means that you can have incredible power over every aspect of the image.

How the Image Forms

Pixels begin on the photo sites of the sensor. The signals from these receptors are transferred through a microprocessor to an analog/digital converter. Once the binary code is produced the data is stored in a camera buffer and/or on a memory card. This data can then be transferred to your computer and to the image-processing program, where it is reassembled as an image. At every stage—by programming how the exposure is translated and by manipulating the image in the computer—you have the power to change the character of the pixels and the "look and feel" of your image. Even so, how you set up the camera when you make the exposure becomes the foundation of the image and in large part determines what you can and cannot do with the image later.

Resolution and Pixels Per Inch (PPI)

If you look at the specifications of a digital camera you'll notice an item called "Resolution Modes" or "maximum effective pixel resolution." You may see a set of numbers like 2898 x 1790, 1536 x 1024, 1024 x 768, or 640 x 480. These represent the number of photo sites per inch in the sensor, with the larger number always referring to the horizontal measure. But what does this mean to you? What implications does it have for the type of photos you want to make? To answer these questions, think in terms of megapixels and the image file size. The megapixel count and the potential file size are interrelated.

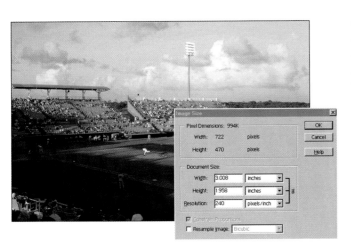

When you make resolution choices before exposure you are in effect making a decision about what you can and cannot do with the image after exposure. I set this photograph up to produce a 1 MB file. It would work in an e-mail or on a web page, but if I wanted to make a print I'd be hard pressed to get anything bigger than a wallet-size image.

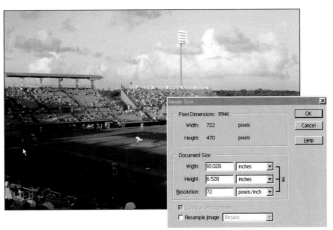

Megapixels

One of the main specifications of any digital camera is the pixel count of the sensor it contains. For most digital cameras this is expressed as a megapixel measure. Mega means million, and the specification refers to the number of pixels the sensor in the camera contains. The higher the pixel count the greater the potential resolution of each image you make. The rule of thumb is: With all else being equal, the higher the resolution, the greater the potential for making larger prints.

To translate the pixel resolution figure into megapixels, multiply the horizontal by the vertical pixel count. For example, say you have a resolution figure of 3000 x 2000 pixels. That equals 6 million pixels, or 6 megapixels. In general, megapixels are a good guide to how big a print you can make. A 3-plus-megapixel camera is good for prints up to 8 x 10 inches. Six-megapixel cameras can yield prints as big as 11 x 14 and even 13 x 19, a common paper size. Keep in mind that the megapixel count is not the only factor in potential print size and quality. The lens, the way the cam-

CHOOSE YOUR RESOLUTION

Digital cameras allow you to choose from a number of resolution levels when you make pictures. You might always want to work with the highest resolution level if your aim is big prints. If you are satisfied with smaller prints, or if you're shooting for a web site, then use lower resolution to create a smaller file size. Here are general guidelines on matching file size to the end use of the image.

Megapixels	Maximum File Size	Best Use
Less than 1	1–2 MB	Very small prints, e-mail attachments, web page images
1	3 MB	Small prints (can also be used for web and e-mail, when lower resolution options are chosen)
2	6 MB	Good 5 x 7 and smaller prints (can also be used for web and e-mail, when lower resolution options are chosen)
3	9 MB	Good 8 x 10 and smaller prints (can also be used for web and e-mail, when lower resolution options are chosen)
4	12 MB	Excellent 8 x 10 and smaller prints.
6	18 MB	Excellent 11 x 14 Prints. The right size for half-page magazine reproduction.
8	24 MB	Excellent prints to 13 x 19 and 16 x 20. Full page magazine reproduction.
14	42 MB	Poster size prints. Double truck (spreads) magazine reproduction.
18	54 MB	Maximum image quality. Displays. Advertising and very large studio portraits.
24	72 MB	Small billboards and display work.

era translates the light to digital code, the shutter speed and overall exposure and the quality of light in the picture also have profound effects. But matching pixel resolution to the use of the image you have in mind is a good starting point.

Just what megapixel rating do you need for the type of work you want to do? If you want to make big prints, purchase the highest megapixel-count camera you can afford. Very high megapixel-count cameras are quite expensive, however, and may be overkill for your needs. There's no reason to commute with a Rolls-Royce, as they say, when a Honda will get you there just fine.

Higher megapixel-count cameras are high maintenance as well, as the file sizes they can produce can fill up your hard drive and eat up the space on memory cards very quickly. So if you buy a very high megapixel-count camera and mostly use it at its highest resolution, be prepared to spend even more money for high-capacity memory cards and big hard drives or storage devices. But if you plan to limit print sizes to 13 x 19 or even 16 x 20 and you use

the camera more for pleasure than business (or if your business doesn't require huge file sizes) then a 5 to 8 megapixel camera will do just fine.

Image File Sizes

Another way to relate to potential print size from a digital image is the image file size. To find the largest file sizes your camera can produce do a little math. All you need do is multiply your megapixel pixel count by 3. So, if you shoot at maximum resolution with a 6-megapixel sensor you will get an 18-megabyte (MB) file when you "open" the image on your computer. Digital cameras that have 8-megapixel sensors can deliver 24 MB files. Digital backs used by pros might have an 18 megapixel or even larger sensor—the 18-megapixel sensor delivers a 54 MB file. Be aware that this is the ideal formula, and that some sensors deliver less usable pixels than their pixel count might imply. The useable pixels are called "effective pixels."

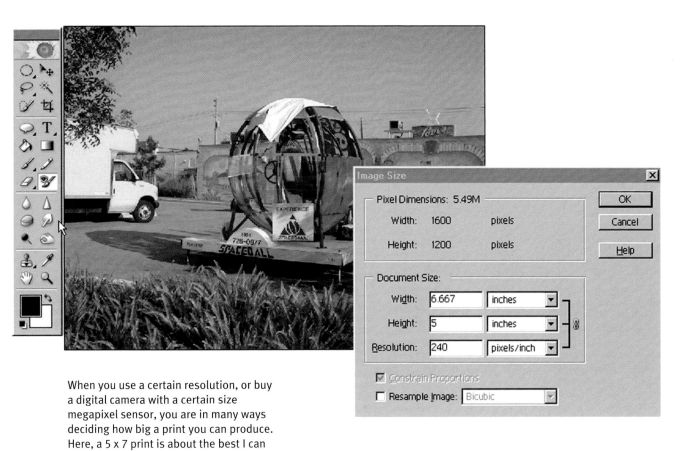

When you use a certain resolution, or buy a digital camera with a certain size megapixel sensor, you are in many ways deciding how big a print you can produce. Here, a 5 x 7 print is about the best I can get with a 2-megapixel resolution.

To understand how file size, resolution and potential print size are interdependent use the Image Size dialog box in your image-editing software. In this series, file sizes of 5.2K, 16.9 MB and 51MB are shown. Note the print sizes you can make from each file size. You probably can get a bit larger print out of all these sizes; test your camera and printer to see how far you can stretch the envelope and still get good results. If you go too far you'll lose sharpness and overall image quality in your prints.

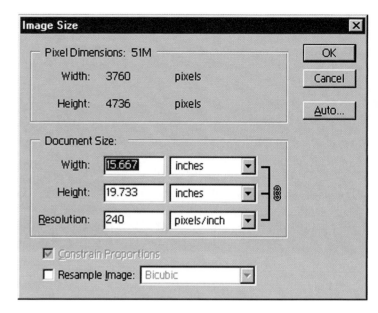

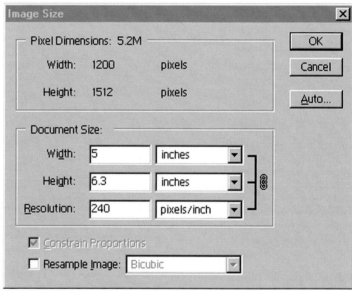

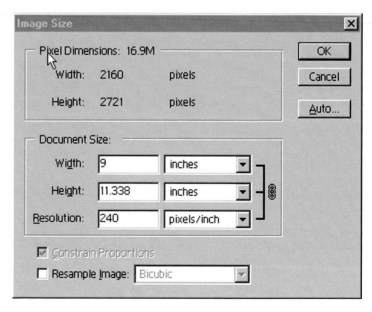

Bits, Bytes and Bit Depth

Computer data is measured in bits and bytes, with a bit being the smallest measure. A bit is binary, which means that it indicates an either/or or on/off proposition. A byte is 8 bits; a kilobyte (K) is 1024 bytes; a megabyte (MB) is 1024 kilobytes; and a gigabyte (GB, or gig) is 1024 megabytes. A black-and-white (grayscale) image is generally composed of eight bits, which define 256 levels of gray that make up a black-and-white continuous tone image. A color image might be composed of three levels of 8-bit information that correspond to the RGB color levels, making it a 24-bit image that can yield about 16 million colors. Some digital cameras can yield 12 bits per channel in Raw mode, which results in a 36-bit image, and some scanners deliver 48-bit images, or 16 bits per channel. TIFF and JPEG images are generally 24-bit images and Raw format usually delivers 36-bit images.

This is all so much computer-speak until you understand the implications of working with different bit depths. As mentioned, it takes 8 bits to describe a level of gray (the shades of gray on a black-to-white graduated scale). When color is added to the scheme, 8 bits is registered in each color channel of red, green and blue. The 24-bit color image is fairly standard as the default output of most digital cameras.

When you photograph with higher bits per channel you are actually getting more information into the image. This usually yields greater color range, more subtle tonal variations and the ability to "play" more when working with the image later. However, as most printers work only with a 24-bit image, it might seem that recording a greater bit depth is a waste of space. Not so. A higher bit-depth image contains more information, so there's more color depth, tonal range and room for creative options.

Does this mean that you're losing out when working with a bit depth of 24? To an extent you might be, but in many instances you might not see a big change unless you are very critical about your work. And some images show the differences more than others depending on your exposure, the lighting conditions at hand and the subtle tonal and color values the image contains.

Resolution Choices

If you are used to working with film you know you can easily get different size prints from the same negative. Of course, there's an upward limit on size and as you go bigger and bigger quality diminishes. In digital photography the upward limit depends in good part on the resolution of the sensor, the resolution level, the bit-depth and the resultant file size that is created.

The often-confusing part is that you can choose different pixel resolutions using the same camera, and remember, the size of the print you make or whether or not you want to use the image as web page determines what the resolution should be. What should you do if you're not sure of the size of the print you will eventually make (the larger the print, the higher the resolution), or if you want to use the image on a web page (which requires lower resolution) or both? Then shoot at the higher resolution, as you can always "shrink" the file size later using image-editing software.

Most digital cameras offer at least three resolution levels. The resolution choice may be stated as pixel dimensions, as resolution modes or even as quality settings.

Unfortunately, no standard terminology is used, so you should check your instruction book to see how these resolution levels are identified. Some show actual pixel counts, some terms such as Good, Better and Best, or Fine and Super Fine, or even a star rating, with one star being low resolution and three stars being the highest resolution offered.

Let's say the camera has three resolution levels and that these are identified as pixel counts. You can multiply the figures to get an idea of the megapixels (for example, 2048 x 1536 equals a bit over 3 million, or 3 megapixels), multiply that number by 3 to determine the file size you will be able to produce and follow the chart on page 42 to match the file size with your desired output. If in doubt, you can always choose the highest resolution available to get the largest prints, the middle resolution size for smaller prints and the smallest size for web and e-mail images. Eventually you will get to know how to match those levels with the kind of results and final print or web output you desire.

Image File Format Choice

Generally, digital cameras offer three file formats—JPEG, TIFF and Raw. Some cameras have only two of these formats. Some offer JPEG and Raw, and others JPEG and TIFF. In general, it's a good idea to choose a camera that offers as many of these formats as possible. While you can live with one or two, having all three gives you the greatest flexibility.

JPEG

JPEG is an acronym that stands for Joint Photographic Experts Group. When you choose JPEG format you can select from a number of what are called "compression ratios" that can range from 1:4 to 1:8 to 1:16 and represent the degree to which the file will be made smaller, or compressed, when it is recorded on the memory card. With JPEG, a 4 MB image records as a 1 MB image at 1:4 ratio and a 500 K image at 1:8.

Compression allows you to get more images per card, but some image information is lost when the file goes through the camera's image-processing system. When you open the image on the computer later, the lost information is reconstructed by complex algorithms (equations) that make assumptions about what "should" be occupying a certain pixel address rather than actually showing what was recorded. So even though a JPEG file might be 1 MB in size, when you open it on the computer it will read larger (in a 1:4 compression, for example, it will read as a 4 MB file). But 3 MB of the information is not the original image information—it has been reconstructed by image processing.

Why, you might ask, should you use JPEG at all if it loses data? In truth, if the compression is low enough you might not notice the loss and reconstruction, especially if you are making moderately sized prints or using the

CONSIDER THE FORMAT PROS AND CONS

Think of making your digital formatting choices as similar to how you might work with film. You choose a camera and film size (35mm, 120, 4 x 5) to match what you intend to do with the negatives or slides later. The same type of practice comes into play when choosing a file format, resolution and compression ratio when you set up your digital camera.

JPEG

Pro: Yields a compressed image, saving space on your memory card, and is an excellent choice for web images and prints.

Con: At higher compression ratios quality in larger print sizes will suffer.

TIFF

Pro: An uncompressed file format that delivers the best image quality at whatever resolution you choose.

Con: Creates the largest file sizes, so takes up space on your memory card.

Raw

Pro: An uncompressed file format that takes up less space on a memory card. After downloading, you can change contrast, color saturation, sharpness and other attributes to customize the image any way you like.

Con: Can only be opened with certain types of image-editing software and usually has to be converted to JPEG or TIFF format for sharing with those who do not have the required software.

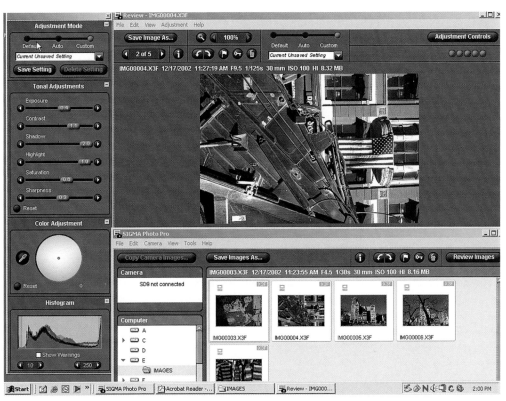

Every Raw browser screen is different but all offer controls for exposure, contrast, shadow detail, highlight detail, color saturation and sharpness. Data displays serve as records of the exposure and camera adjustments when the image was made.

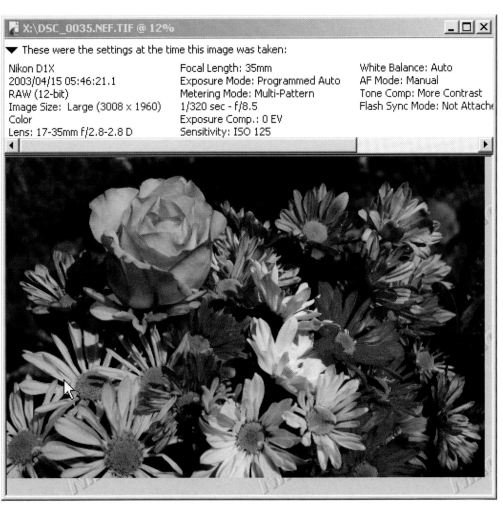

X:\DSC_0035.NEF.TIF @ 12%

▼ These were the settings at the time this image was taken:

Nikon D1X
2003/04/15 05:46:21.1
RAW (12-bit)
Image Size: Large (3008 x 1960)
Color
Lens: 17-35mm f/2.8-2.8 D

Focal Length: 35mm
Exposure Mode: Programmed Auto
Metering Mode: Multi-Pattern
1/320 sec - f/8.5
Exposure Comp.: 0 EV
Sensitivity: ISO 125

White Balance: Auto
AF Mode: Manual
Tone Comp: More Contrast
Flash Sync Mode: Not Attache

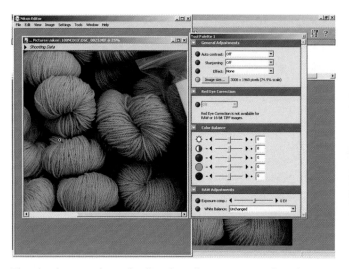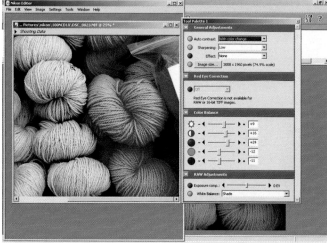

The simple control panels allow for adjustments to color, sharpness, contrast, White Balance and even Exposure Compensation. Changing these settings in RAW software is just like making adjustments in the camera when you make an exposure. The adjustments you make are previewed as you make them, and the original file remains untouched.

image for web and e-mail. JPEG is the preferred standard for web transmission because it can be used to make smaller file sizes that look quite good on the screen.

To see if JPEG can do the job for you run a series of tests. Photograph at various compression ratios and then make the size prints you like. See when image quality suffers and the limits of compression that make for acceptable web images. At lower compression ratios (and the highest resolution) JPEGs can deliver good prints. But keep in mind that overusing compression will result in some degradation of detail, color and sharp edges.

TIFF

In some digital cameras the only choice you might have other than JPEG is TIFF file format. TIFF is an acronym for Tagged Image Format File. Unlike JPEG, TIFF files are not compressed and carry with them all the recorded pixels. TIFF can be read by virtually every image-editing software program, delivers high-quality prints and is considered the de facto standard among photographers, art directors and picture buyers.

Keep in mind, though, that high-resolution TIFF files can get quite large. For example, if you have a 6-megapixel camera, the TIFF files sizes in RGB will be about 18 MB. This is way too large to transmit unless you have dedicated lines to the server or client. TIFF files are best sent via a burned CD or other media. Also, be sure to have enough memory capacity to carry you through a day's work (if in the field) or carry a portable download and storage device, such as a laptop or memory bank, with you.

TIFF and JPEG files are processed within the camera itself. This does not prevent you from changing the image

characteristics later in an image-editing program. But it does mean that whatever attributes you add to the image, and whatever color shaping you choose or is used by the color processing system in the camera, will go along with the file. In addition, both TIFF and JPEG files are processed in the camera as 24-bit files, unlike Raw files, which offer information-rich 36-bit files.

Raw

More and more digital SLRs and higher-end digital cameras of all sorts are utilizing a file format known generically as Raw. Raw is short for raw image information, but different brands might refer to the format by different names; Nikon calls its Raw files NEF (Nikon Electronic File) while Sigma calls its X3, named after the Foveon chip in the Sigma digital SLR camera.

Raw files are uncompressed like TIFF files, but are not processed within the camera. Raw files may carry thumbnails (small images) of the captured images and what are sometimes called an "instruction set" that holds the settings (such as aperture, shutter speed, ISO and other such data) used when the image was made. These sets are attached to, but not necessarily embedded in, the image file. Because they are not processed in the camera, Raw files, while uncompressed, are smaller in file size than a TIFF file shot at the same resolution. This means they take up less space on a memory card.

One disadvantage to Raw files is that they must be opened using special software supplied by the camera manufacturer or a third-party maker. While many image-processing programs, including Photoshop, now offer Raw accessibility, not all do, and not every one who might

THE POWER OF RAW

With Raw software, you can make the following image adjustments and effects, giving you a great deal of creative control over the look of the final image.

White Balance : When you bring a Raw file into the Raw converter software you can choose any White Balance (the rendition of color under a certain type of illumination you desire; see page 18). You can change the White Balance that was set on the camera, select a specific White Balance point to very specific color temperatures (such as 3256 degrees) and even identify a neutral gray within the image and use it to set the White Balance for you. You can balance out the red and blue light components to get exactly the color bias effect you desire. This is an extremely powerful color correction and enhancement tool and in itself is worth the price of admission.

Noise Reduction : In Raw software, Noise Reduction filters (see page 26) offer more control than the camera software because it is not a preset effect but one that you customize to get just the amount of reduction you desire. You can even apply the filter to a number of images at the same time using the Batch and Load commands.

Color Balance : Though akin to White Balance, the color balance control allows you to set specific degrees of hue and saturation for all the primaries (RGB) and to alter their contrast and brightness as well. In most cameras the hue and saturation menu allows for a non-defined degree of change in plus and minus increments. This control, similar to those in image-editing programs, gives you complete control over each color channel.

Exposure Control : In Raw software you can make highly specific changes in Exposure Values (EV; see page 12) to enhance lighting and mood, such as a +.87 EV compensation. This gives you tremendous control over the exposure after the image has already been made.

Curves Control : Curves control in Raw format offers a wider dynamic range (see page 150) than TIFF and JPEG formats do. As a result, you have more leeway in what you can bring out in shadow and highlight areas. For example, Auto Adjustment enables you to stretch the values across the tonal scale of highlights and shadows. The Curves control may also extend to color contrast, which allows you to set each channel individually (RGB). If you want to set the Curves yourself you can do so to "tweak" the image to any contrast you desire. You can also use the Middle Gray Point control to set the values wherever you like. Some Raw converter programs allow you to access these controls with a tone curve graph while others work mainly from a Histogram type control.

Sharpening : Raw converter software gives you much more finite control in sharpening and softening images (see Chapter Four).

Size and Resolution : Most Raw software enables you to take the original Raw file and change it to whatever size and resolution you desire without affecting the original image information. Some Raw programs also use a "smart" resizing function that can be used to increase the image file size (to get bigger prints) with a minimum of degradation.

receive images from you has the required reader. (TIFF and JPEG images can be accessed directly by most image-editing software and e-mail system; some software aimed primarily at the amateur market may recognize only JPEGs.) In addition, many Raw formats are 16-bit, which may block certain image-editing capabilities even on more advanced software programs. Converting to 24-bit (from 16 to 8 bits per channel) creates more access to more software features.

This drawback aside, Raw file format is probably the

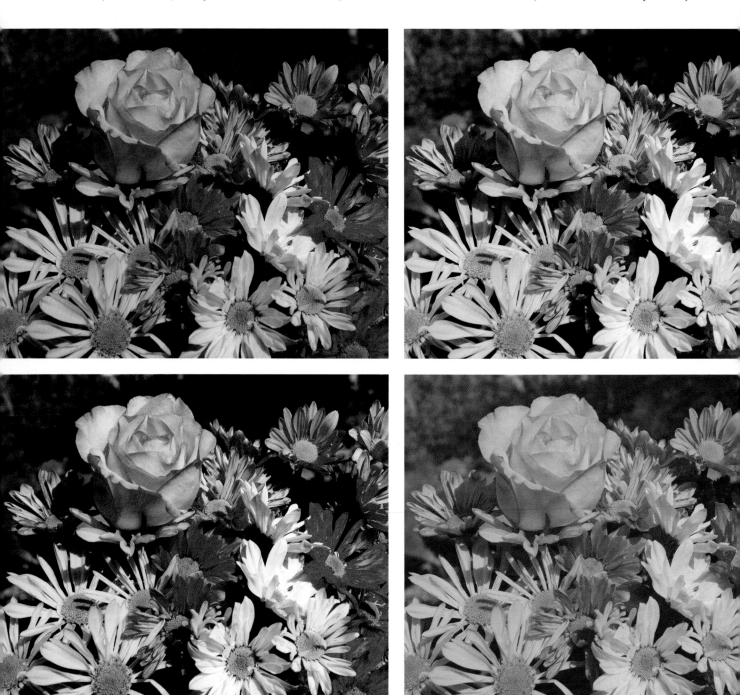

(Left to right, from top left) I put a Raw image I photographed with a Nikon D1X through a series of changes using Nikon Raw software: 2/3 EV Exposure Compensation; changes in White Balance controls, first the tungsten White Balance chosen here, then a warmer rendition created by setting the White Balance on "cloudy"; an increase then a drop in contrast by one stage in each direction; a one-stage increase in sharpness; and even a change to sepia.

best for your digital images, provided you are prepared to take the time to download and convert them. Think of a Raw format image file as you would a negative or slide you will process yourself. Some people characterize it as an undeveloped film negative awaiting processing in the computer. Once you have your Raw image inside the Raw converter software you can manipulate exposure, contrast and tonal values as well as color, White Balance, sharpening, noise and even the distribution of light throughout the scene (vignetting control).

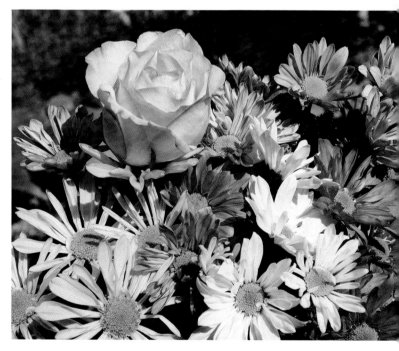

Digital Camera Controls

THE VARIOUS DIALS, MENU ITEMS AND PUSHBUTTONS on your digital camera are the keys to the amazing world of digital imaging. Some of these controls are on the camera body, others are only available within the menu selections. These controls help determine file size and format, as well as image characteristics. You can alter many of these attributes later with image-editing software, but the point is, once you become comfortable using these controls as you shoot, you'll be on the road to making spontaneous pictures that have a personal touch.

Learning the Basics

Recording:
Format, Resolution
and Compression

Color Reproduction

Three Basic Controls:
Sharpness, Contrast,
Color Saturation

Noise Reduction

Bit Depth

File Number
Sequencing

Image Review

Special Effects

A stack of metal and plastic chairs is a good subject for Posterization, one of many special effects you can achieve with digital imaging.

Learning the Basics

Some of the photographic controls (aperture, shutter speed, autofocusing setups) will be very familiar to you if you have worked with a film camera. Yet each camera model is unique in the way you make exposure and focus settings. In some, aperture settings are made by turning the ring on the lens itself; in other cases you lock the lens at the minimum aperture and control aperture by the command dial on the camera body. Shutter speeds are generally available via the same command dial, or a sub-command dial.

Usually, the more common controls are available right on the camera body, while more unique controls are accessed via the menu. You probably want to work with a camera that has the most "photographic" controls on the body, such as changing ISO, exposure compensation and even choosing resolution modes. Always having to go to the menu to apply these controls can get in the way of spontaneous photography. On most cameras you can customize the ways to access these controls—for example, you can make changes so you can access the aperture from the command dial and the shutter speed from the subcommand dial, or vice versa.

The first step is to read your instruction book carefully. Take the time to learn how to take the best advantage of these controls so you'll be able to capture the images you want.

In your workflow you should be at ease with the following:

- Setting ISO

- Changing aperture and shutter speed

- Changing the metering pattern

- Choosing a focusing target, or using AFL (autofocus lock)

- Setting autoexposure lock

- Selecting an exposure mode

- Using exposure overrides

- Setting up resolution, format and compression.

Digital Setup Controls

The main controls for setting up for digital photography can be divided between image format and image attribute options. Formatting means choosing resolution, file type and compression ratios; this is something you do with every image you shoot. Image attributes means programming the onboard image processor to change the information received from the sensor in a number of ways. The sensor in your camera is basically a receptor of light and provides a signal that indicates brightness, color and the overall tonal value at each photo site. Once the signals are transferred to the image processor they are translated into code that identifies a certain level of color saturation, contrast and other attributes. If you shoot with JPEG or TIFF formats you have chosen to have the image processor in the camera handle a certain amount of image identification tasks. If you choose Raw format, however, you are saving that processing until later when you get the image into the computer. Either way, you still have more options when you get the image into your image-editing program in the computer.

WHERE TO PROCESS

There are different schools of thought on whether to do the image processing and add image attributes in the camera, in the computer, or both. Some photographers want to nail down the image attributes before the image leaves the camera; others want to wait until later to make decisions. The best advice is to work both ways—with JPEG or TIFF formats with assigned attributes and with Raw, which delivers the basic image information without any particular character. Then you can judge how the camera processes the image and see which way works best for you.

Setting Controls

On most digital cameras, the main menu options are generally known as Recording, Playback and Connectivity. There may be other names for these options, such as Setup or Format. You may also be offered Custom controls, which allow you to set up such items as monitor brightness, bracketing order or the degree of change within a bracketing sequence.

- Recording options include file format and resolution, ISO, sharpness, color space and other image attributes you might want to assign.

- Playback options include the size and number of images that you can display on the monitor, the ability to delete or "lock" images, and, in some cameras, the opportunity to display a Histogram when reviewing your images.

- The Connectivity menu is really a "sending" or output option, and its how you get your images from the camera to another drive, such as your computer.

There are no standards for how each camera maker displays or identifies these options, so check your instruction book to learn how each is named and accessed with your camera.

With advanced cameras, you can usually access such functions as Exposure Compensation, Autofocus, Flash and Exposure Mode from dials and buttons on the camera body, rather than from a harder-to-use monitor menu. The LED serves as a guide to these functions and shows the changes in settings as you make them.

Many cameras allow you to set digital controls using dials and buttons on the camera body; this menu from a Nikon digital SLR shows the resolution and file format settings, White Balance settings, the ISO and the memory bank settings.

Recording: Format, Resolution and Compression

The Recording option allows you to select the file format, resolution and compression of each image you make. On some digital cameras this control is on the body, while in others you access it through the LCD menu.

Recording is the first digital menu item that you should gain comfort with, as you will want to be sure that you are recording the correct file size and format for each image you make. Be aware that each model camera uses a different nomenclature, so familiarity with how your camera indicates file size and format information is important; some cameras, for example, do not indicate the actual file size, but use terms such as "Large," "Fine," "Medium" and "Basic." Always check your instruction booklet.

Various resolutions can generally be selected within each recording format, although some cameras limit choices within the TIFF and Raw formats. JPEG format has the most choices, and you can shoot in an often dizzying array of options, including resolutions from, say, 640 x 480 (for web images) to 1600 x 1200, or whatever

the upper limits of the resolution of the chip might be. You also get to choose compression when you work with JPEG, which can range from 1:2.7 to 1:4 to 1:8 to 1:16 or even higher.

Part of working with any photographic system is testing the limits of the recording medium. One of the first exercises you should do is to try out the different format, resolution and compression options on your camera and learn how each might affect the quality of what you want to do with the image. Working with all the options in an efficient manner saves both memory card space and the necessity to rework the image later when you go to make a print or a web image.

Try making a portrait, a still life, a landscape and a copy of a print or painting using the various options in the following chart. (Note that not every camera will offer all the options shown.) The point is to give your camera a workout and see how it performs; then you will know what you can and cannot do at every level of resolution and compression and with every format you have.

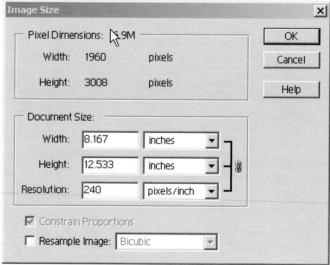

Your choice of resolution has a profound effect on what you can do with the image later. If your aim is large prints, photograph with the highest resolution possible in TIFF, JPEG (low compression) or Raw modes. This photo was made at 3008 x 1960 pixels and creates a file of nearly 17 MB. When the Image > Size box is opened in Photoshop, the print size at 240 ppi is 8 x 12.5 inches and can be made as big as 11 x 14 with some pixel manipulation (resampling). At this size there will be no evidence of artifacts or loss of edge sharpness.

Resolution	Format	Compression
Highest	Raw	None, but try if available
Medium	Raw	None, but try if available
Highest	TIFF	If available
Medium	TIFF	If available
Highest	JPEG	1:4 (or lowest compression)
Medium	JPEG	1:4
Lowest	JPEG	1:4
Highest	JPEG	1:8 (or medium compression)
Medium	JPEG	1:8
Lowest	JPEG	1:8
Highest	JPEG	1:16 (or highest compression)
Medium	JPEG	1:16
Lowest	JPEG	1:16

Once you have made this set of test images bring them up full screen on your monitor. Then make a set of 8 x 10 inch prints at 240 dpi. This is one sure way to see just what each of these choices delivers. Having done this test you will be able to choose your file formats, resolution and compression with an understanding of the implications of your choices.

You might notice a difference in how your choice affects each type of subject matter. Images with lots of detail and tonal variation and subtlety of color will do better with higher resolution choices, while you might be able to get away with slightly less resolution for other subjects. Keep in mind, too, that if you shoot full resolution with a JPEG that the image will "open up" with the full file size, even though the compression shows up in the file size in your Image Folder. The degree of compression you use will determine how much information drops out of that file when you open it. Always save the JPEG file as a TIFF when you close it if you do any image changes—even if just rotating it.

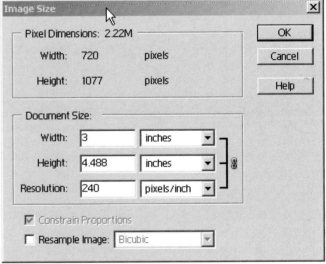

This photograph of a cement mixer was made at a low resolution—1077 x 720 pixels—resulting in a 2.2 MB file. Stretching this image file size to even 5 x 7 would be chancy, as the fine line and detail would start to break up. Take the time to experiment with different resolution sizes by making a series of images and printing them to different sizes. You'll soon see the importance of choosing the right resolution to make the size prints you desire.

Color Reproduction

Different cameras offer varying ranges of colors that can be reproduced through digital imaging. Adobe RGB is the best option for general print photography. Another option is sRGB, which narrows the color options somewhat but delivers colors that are more saturated. This is usually the default "color space" of digital cameras. Some cameras have an additional sRGB/Landscape mode, which actually intensifies (adds more saturation) to blues and greens.

Of course, the camera itself has a lot to do with color quality, and some image processors, usually those on higher-priced cameras, deliver better and truer color than others do. Format is also a big factor. Raw format delivers as full a color gamut as you can get from your camera. JPEG necessarily cuts down on the color gamut as it compresses images, although the differences might not be that apparent.

White Balance

Think of White Balance controls as replacing the color correcting and color balancing filters you use with film cameras. If you photograph using Raw mode you can perform all sorts of White Balance control in the Raw reader and editing software. If you photograph with other formats it's a good idea to work with White Balance controls as you shoot and test how each setting might affect your images.

Your camera has programmed White Balance settings. The problem, though, is that White Balance settings are generalized but lighting conditions are anything but generalized. Say you set White Balance for "cloudy" to add some warmth on an overcast day: The camera's adjustment for "cloudy" might be of a certain color temperature while the actual counterbalancing setting might be a few hundred degrees different from that setting. These subtleties usually make little difference to most photographers, but if you're finicky or need to have absolute White Balance control for commercial photography, then the only reliable way of getting precise White Balance is to use the Custom White Balance setting and make the readings and settings yourself.

It's quite simple to make a Custom setting. All you need do is set White Balance at Custom and then read a white paper or shirt or other control strip and press the shutter release. The camera system will then act like a color temperature meter and yield a White Balance setting that perfectly matches the ambient light it "sees." Each subsequent shot will work with this color temperature setting, until you take the White Balance off Custom or, with some cameras, when you manually power down (as opposed to letting the camera go into sleep mode). If you shoot in Raw format, you need not set White Balance until you've downloaded the image into the software.

A WHITE BALANCE "CARD TRICK"

Here's a way to use Custom White Balance to set up individual color casts on images. Get a pack of color cards, matte surface, that range from primaries to pastels to highly saturated color combinations. Go through the Custom setup and use various color squares to make your setting, being sure to fill up the frame with the color card when you do so. (Focus settings are unimportant; don't worry if you can't focus close enough to make the card sharp.) After you make each setting, each subsequent image will be cast in the complementary (opposite) color of the card. Thus a green card will yield a magenta cast, a blue card a yellow cast, etc. Just what cast you get will depend on the color of the card. This technique allows you to have dozens of colors available in your custom settings.

Of course, you can always adjust color cast after you have made your image in the computer. You can get "true" color or add color mood to an entire or select portions of an image. Color correcting a really "off" color is difficult, but minor corrections in most image-editing programs is no problem. In short, don't worry too much about setting your White Balance exactly for each photograph; autoexposure will usually deliver what you want. Rather, use White Balance as a fun tool and as a built-in filter set.

etting Temperature

ou can use White Balance settings as you might use "cc" color biasing filters on film cameras. For example, if ou are photographing fall foliage and want to add more armth to the scene, or simply like "warm" portraits, you an use the flash setting (without using flash) for a slight touch of warmth. If, on the other hand, you want to add a cool touch to images, go with the incandescent or tungsten White Balance setting.

On page 61 I have included a chart showing a typical Kelvin color temperature setup for various White Balance settings.

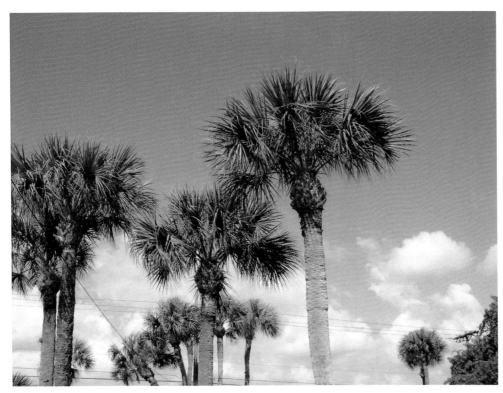

Some digital cameras allow you to enhance one channel of color (RGB) while not affecting others. I first photographed this scene using Autoexposure and default (normal) color controls then with a plus-one blue enhancement. This deepened the blue sky and changed the green slightly (as there is some blue in these greens) but otherwise did not affect the results.

A photograph of an alcove in poet Robert Frost's home obviously needed some fill flash for a good exposure. The fill gave the interior a cool, blue cast, but putting the White Balance on Flash corrected the bias in the camera. This procedure saves processing time in the computer later.

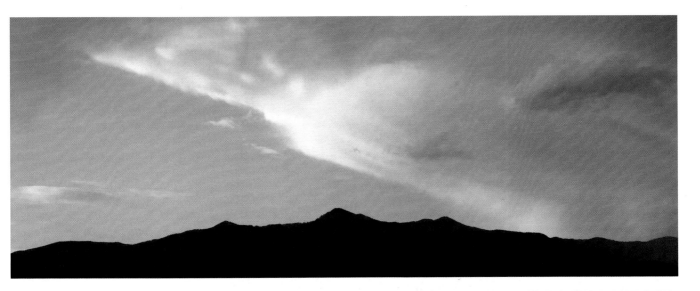

You can manipulate White Balance to function as an on-lens filter. I first photographed this scene with Auto White Balance then with a warmer Cloudy White Balance setting. The effect is the same as if I had placed a light yellow filter over the lens.

A SAMPLE KELVIN COLOR TEMPERATURE SETUP

Degrees Kelvin	Lighting
1500 K	Candlelight
2700 K	Indoor light bulb
3400–4000 K	Dawn and dusk
5000–5500 K	Mid-morning or afternoon
5200–5600 K	Sunlight at midday
6000–7500 K	Cloudy, overcast sky

Note that making White Balance settings might not result in "true" color rendition due to variations in the light source, the atmospheric conditions, the age of lamps, etc. In this chart the color bias of the scene goes progressively "bluer" from lower to higher color temperatures. Setting these temperatures in White Balance controls works in opposition to the prevailing light, so as you set a higher color temperature the effect on the image is to add more yellow.

Three Basic Controls

Sharpness

Sharpness in digital "camera-speak" has nothing to do with fixing a blurred image and has nothing to do with the autofocusing system in your camera. Sharpness here refers to what might be better called edges, the border between neighboring tonal values, be they grayscale or color. There are generally three sharpness setting available—default, or "normal," plus-one sharpness and minus-one sharpness.

The default setting is simply the factory's setting. Some chips and camera systems seem to deliver crisper images than others, while some are too sharp (have too much of an edge effect.) Some cameras are notorious for delivering "soft, mushy" images. But it's easy to compensate with modifications to the default setting or with editing software. Test to determine whether you should add sharpening in the camera setup or in the software; if the amount of sharpening needed is less than the plus-one setting your camera provides, you'll be better off sharpening with the software.

If by happy coincidence the sharpen default setting in your camera is on the money and you don't choose to make any corrective settings, you can use the Sharpen menu creatively. You might choose a minus 1 setting for portraits, or a plus one for urban landscapes or graphic subjects, such as wall posters. Sharpening is a contributing factor to color richness as well, although the contrast and saturation menu settings can also play a part.

Your image-editing software provides complete control over sharpness and allows you to apply it as needed to each subject and scene. Choose Unsharp Masking (or similar function in non-Adobe products) in your program to sharpen to taste and modify the settings to any degree you desire.

You can combine in-camera controls for enhanced image effects. To bring out the detail in a faded painting on the Berlin Wall on an overcast day, I applied a plus-one sharpening and plus-one contrast.

▶ You can choose to sharpen images in camera. As you work you'll begin to recognize those subjects that can be enhanced by this technique. This photograph is all about lines and forms. The second version was made with a maximum sharpening setting (plus two) in the camera. Note how the edges become "crisper" when sharpening is applied.

Contrast

Contrast is the relationship of brightness values within a scene. High contrast means that there is a fairly wide range of brightness between the highlight and shadow values, while low contrast indicates little difference. Contrast also contributes to color richness and a sense of sharpness; higher contrast images are perceived as sharper than lower contrast ones.

The contrast setting options of digital cameras vary according to model. Some offer a simple default, plus and minus one range, while others go as far as a plus/minus two range with degrees of contrast control offered over the entire range. Going to a higher contrast setting compresses the tonal values on both ends of the scale, while, in theory at least, a lower setting spreads those values. But values cannot be spread beyond the ability of the sensor to record a certain range, so minus contrast is generally used to suppress bright highlights in high-contrast scene conditions.

Some digital cameras have image processors that deliver a decidedly "contrasty" image, done to add some "zip" to the image. This might, however, result in excessive contrast in even normally lit outdoor scenes and become exacerbated in high-contrast scenes; in this situation, capturing highlight detail can be difficult. Try suppressing contrast by going to a minus setting in the menu; the degree required should be tested with the camera. If your camera continues to deliver harsh, high-contrast images, the problem might be with the chip, the lighting conditions you shoot in or the image processor. Conversely, shooting on an overcast day with any camera, film or digital, can result in drab color and poor tonal spread. Try out the Plus-one Contrast setting to enhance color and delineate edges; this setting is apt when photographing in deep forest. Remember, it's much easier to add contrast to "flat" images than to correct for harsh images later.

You can get a good sense of contrast range by taking readings of the significant shadow and highlight with texture (as opposed to spectral highlight) and noting the difference in stops. You can also make an exposure and judge contrast using the Histogram of the image, a graphic representation of the tonal spread and distribution of brightness values within the scene (see page 83).

Tonal Compensation

One way to compensate for contrast problems, or to set contrast as you like it, is through Tonal Compensation Curve controls, offered in some advanced cameras. You might be familiar with Tonal Curves from technical bulletins on film or from studying how development affects contrast. The curve plots out highlight, midtone and shadow values in a scene.

You can usually choose from preset Tonal Curve adjustments or create your own Tonal Curves via the camera software. You must attach the camera to the computer to do this. Once you create the Curves you place them in a memory bank in the camera and load them when required.

These Curves are what you might call picture or project specific. For example, you can set up a certain Tonal Curve for a set type of portrait lighting, or create a Curve for document copying or landscape work. You can also set up highly creative Curves for special effects, such as solarization in camera. You can do much of this work in your image-editing software, but there may be times when setting up specific Curves can save you computer-processing time later. This creative control can be lots of fun and is really a way of "reaching into" the camera's image processor and programming it for very personal needs.

Adding contrast in the camera is like printing with a higher contrast paper in the darkroom. Test your camera to see the effects of adding various degrees of contrast. I enhanced this photo by adding plus-one contrast.

Color Saturation

Film photographers who shoot color slide film will have an innate understanding of what color saturation means—it's part of a film's personality. Think of color saturation as a measure of how vividly you might want to render color. Low saturation can be thought of as pastel or any color mixed with white, while high color saturation describes a freshly painted wall or the dazzling color induced by bright, winter light. The color in the scene itself will determine just how much saturation can be enhanced or reduced, and certain colors will respond to this command more than others.

Saturation adjustments in camera are generally available in default (neutral), minus one (less saturation) and plus one (more saturation) options. Do tests with your camera to determine how much saturation is eliminated

Color Saturation controls dictate the degree of color vividness you want to add to an image. Here a change in settings by just plus one makes a considerable difference.

or added with each setting. Test with portraits (where a minus one setting can be useful) and scenes such as fall foliage (where a plus one saturation will really brighten colors). You can easily adjust for saturation using software after the image is made, so adjust for saturation sparingly and only when you are certain that the look you are after will best be created using the Saturation controls in the camera.

Reducing color saturation can create an image that is almost monochromatic. Not every subject will benefit from this effect, but when the opportunity arises you should take two photographs, play with color saturation and compare the results.

Noise Reduction

Whenever you shoot with a very high ISO or when you make long exposures at night you are probably going to be introducing a certain amount of noise into the image. Noise manifests itself as specks of color, dropouts or even crossed colors that seem to bleed along tonal borders. Noise in higher ISO settings comes from the greater gain you set up across the sensor's electrical field. In long time exposures noise comes from electrical static that may play across the sensor field.

Some cameras automatically set a Noise Reduction "fix" in such conditions, and you have to turn it off by accessing the menu controls; on other cameras you must turn on the Noise Reduction feature. Noise Reduction analyzes the image information and detects the noise pre-sent. The feature then extrapolates image information and "smoothes out" the noise, usually by sampling adjacent pixels for information and applying that information to the affected pixels. Unfortunately, the number of calculations required to detect and correct noise can result in lengthy processing times, preventing you from shooting other images until the corrected image has been processed and put away. Some cameras automatically put the Noise Reduction image into a buffer to allow you to shoot more images, but the number of subsequent images you can shoot is limited by the buffer size. In Raw format, you can turn off Noise Reduction in the camera, keep shooting at a rapid pace, and make adjustments in the software editing stage.

Bit Depth

Bit depth is another topic that stirs some debate. In some cameras you can choose to work in Raw (with 12 or 16 bits per channel) or in JPEG or TIFF, with 8 bits per channel. Simply put, the more bits you have the more information is available in color and tonal values. Working in a higher bit depth also seems to handle highlights better, as there's a necessarily wider recording range. In essence, working with higher bit images gives you more creative leeway later.

Some cameras may actually capture in 12-bit but compress the image to 8-bits per channel during image processing in the camera. This is the knock against JPEG and TIFF, which always bring the image down to 8 bits per channel regardless of the capability of the sensor. But can you actually see the difference between the two (8- and 16-bit) when you go to print? In truth you may or may not, depending on how demanding you are and how your image-editing software handles the image information. Working with higher bit image files always slows things down a little, at least in comparison to 8-bit workflow; some image-editing software programs do not handle 36-bit (or the converted 48-bit) images at all, or restrict what you can do with them.

It's best to test and see if there's any difference in making this choice and how it affects your expectations of image quality. The good thing about higher-bit-depth images is that they start out with more information, giving you more leeway in what you can do with them later. The negative aspect of higher bit depth is that it slows your work down, takes up more memory and may not have as profound effect as you might think. Having more options is always good. But do you need the larger file sizes and expanded information for every image? That's only for you to say.

File Number Sequencing

Although we'll go into image organization in detail in Chapter Seven, you should make file organization part of your setup before you start making pictures. When you download images each file will be named, for example, as CIMG004 or whatever prefixes a camera maker uses, followed by the order of images made. The images will also carry a suffix indicating the file format, such as (.jpg) or (.tiff).

You might have a choice to set up the camera so that the recording sequence will start at 001 on each card or start at the number left off when the card was removed for downloading or reformatting. It is a good idea to choose sequential numbering, as this will help you differentiate files from each card and eliminates the possibility that the software will overwrite files with the same identification number and code. Another identifying factor is the date and time of the download or the date when the image was exposed, so always be sure to have your time and date stamp set before making pictures. Make sure that the date and time stamp does not appear on the image; this procedure tags the image file rather than imprinting the information in the image itself.

As you make images on successive memory cards you have a choice of having the card begin at "0000" with each new card loaded or to program the camera to number images sequentially even when you replace the card. It's your choice, but choosing the sequential numbering scheme helps make every image identifier unique.

Image Review

You can always tell when someone is using a digital camera because right after the shot the photographer will tilt the camera back and hit a button to see the image. The instant review feature is one of the most appealing aspects of digital photography and you'll come to count on it to help you figure out exposure and composition.

The problem is, the LCD finders on most cameras are quite low resolution, making it difficult at best to check critical focus. The LCD will not always give a very good indication of exposure because it is often quite difficult to read in bright light. There are several solutions to these problems. One is to know how the LCD readout compares to the actual recording and adjust the LCD brightness accordingly. Some monitor displays can be tilted, so you can make the most out of the lighting conditions to make a reading. In bright light, you can place an accessory hood over the LCD to block out stray light, much like a "black cloth" that is used to focus and compose with large format cameras. In addition, new technology, known as an "organic" LCD screen, is much superior to the older types and more cameras will have this or similar display technology.

Given these limitations, however, the instant review can be helpful in saving memory card space by allowing you to delete the obvious missteps. It is also useful when sorting and deleting later after the photographic session is over, hopefully under better lighting conditions.

There are a number of options in Review mode. One of the most used is the delete function, usually indicated by a trashcan icon. When the delete button is pushed a prompt will usually ask whether or not you are sure you want to discard the image. This may seem like an unnecessary step, but it's a failsafe option that can help save an image that you reconsider as you go.

You can lock or protect certain images from deletion, so if you want to clear a card you can do so without losing those you have protected. This is a much quicker method than having to delete one frame at a time. This usually does not protect images if you choose the Format Card option, which clears the card of all images. Format only if you place a new card in the camera or want to wipe the current card clean. Keep in mind that you can usually rescue images using recovery software if you just delete them, but rarely will recovery software rescue images from a card that has been formatted.

If you'd like to review all the images without having to continually push a button to go from one image to the next you can choose the Slide Show review option. This plays the images in sequence and is a great way to share the images with others. You can change the duration of each image on the screen from a second or two to as much as ten seconds. This also allows you to review the whole session before you start deleting and protecting.

A number of cameras also allow you to zoom into and move around an image, and this is a great way to check if eyes are open on a group portrait or if focus is right on a macro shot. You can also skip quickly from image to image or look at six images at a time on the screen if you desire, though you'd be hard pressed to see much of anything in terms of detail with that viewing option.

One word of caution about Image Review: There may be times when an image looks awful on review on the LCD and turns out to be quite good, or at least salvageable, when the image is opened on your computer. This seems often to be the case with images that seem underexposed (dark) on the LCD. Often these images contain all you need to make a good print or screen image later. Keep in mind that unless viewing conditions are optimal the LCD is at best an indication of the images you have recorded.

Special Effects

If you enjoy creating special effects you have many options with the images in your camera. Your menu may include such functions as recording in black and white or sepia; creating color effects, such as adding saturation to red or blue; solarization; pen and ink, and many others. These special effects might be identified as special modes or functions, or you may be able to use the available settings in creative ways (see the instruction manual that comes with your camera). Don't hesitate to experiment with lots of options and combinations—you never know how an image might turn out.

Keep in mind, though, that the number of effects available in your camera pales next to those available in imaging software. So don't box yourself in—or force yourself to work backwards out of a set of image parameters you set in the camera—by choosing special effects when you make the image. Experiment, but understand that you can probably accomplish more later, when working with software.

Some cameras offer a special mode for making document copies, or for setting very high contrast. Combining the Copy mode with a Black and White picture mode yielded this pen-and-ink rendition of a winter scene.
Photo: Grace Schaub

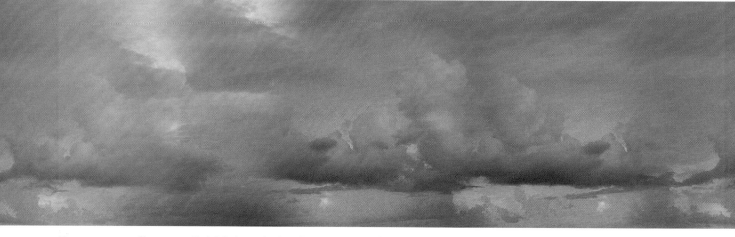

Many cameras offer a so-called Stitch mode that directs you in making a set of overlapping images. You can also make a set of images without using the Stitch mode and, as I did with this scene, put them together later in editing software.

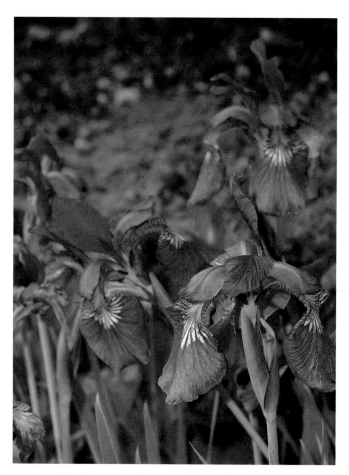

You can affect the mood of every subject and scene using a combination of camera and software controls. In some cases you might be able to accomplish this in the camera, such as I did with these images. I set contrast at plus 1 and saturation at plus 2 and the "daylight" White Balance setting for the flash. I then achieved an entirely different mood by setting contrast at minus 2 and color saturation at minus 1 and using flash on the "cloudy" White Balance setting. I added a slight bit of soft focus later by using a blur tool on the entire image in an image-editing program.

Slimming mode squeezes and stretches images right in the camera—aside from creating interesting cityscapes, the mode is also good for taking a few pounds off subjects. I made the image on the left with Slimming mode and enhanced it further in Photoshop with a special-effects filter.

Use the creative modes in your camera to make any number of variations on a scene. I first shot this cityscape using the default settings on the camera, then used the Solarize option, Black and White mode and, finally, Black and White mode with a plus-two contrast. You have the choice to create these effects when you make the photo or later in imaging software.

Digital Exposure Techniques

Exposure Basics

Contrast

Metering

Flash

IN THIS CHAPTER WE WILL LOOK AT ASPECTS OF exposure that are unique to digital photography and see how format choices and exposure-reading techniques can help you get the most from every subject and scene. Your aim and goal should be to record as much of the tonal, color and brightness values you can. That way you have more creative options later.

The use of plus-one Exposure Compensation brings just the right exposure to this scene. Failure to compensate would result in a gray, rather than white, wall and underexposure of the implements on it.

Exposure Basics

Why learn exposure techniques when many digital cameras "preview" the exposure on the monitor before you press the shutter release button? All you need do is press lightly on the shutter release and hold it and the screen will show you a general indication of how the different values will record. And if you make an exposure mistake, you can always review the image and correct it on the next shot. Keep in mind that "indication" is the operative word here, as what finally ends up being recorded might be quite different. Besides, if you photograph in bright light it can be difficult to get a good read on the LCD. The point is, learning good exposure practice is the best assurance that you'll get what you want from every subject and scene.

Dynamic Range

When we make a sound recording we do everything we can to bring in the greatest range of bass and treble, to be able to reproduce, for instance, the piccolo and tuba. The same goes for light recording, where we seek to record as wide a range of brightness values, from light to dark, as we can. This spread of values is often referred to as dynamic range. Just as the placement of the microphone and the ability of the recording heads and tape to encompass all those musical tones determines the quality of a sound recording, photographic media impose similar limitations on the dynamic range of a photograph.

Many digital cameras provide excellent dynamic range and do very well under overcast conditions, such as this scene photographed with fog rolling through the woods.

These metal objects show every bit of texture and color, a good indication that the exposure system and camera are delivering a good range of values. Fill Flash helped to open up shadow areas in this scene.

In your digital camera the dynamic range is determined by the sensor as well as by the way in which the image information is processed, with both playing an important role. Dynamic range is also determined, in part, by the format you choose to make your recording. If you choose a 24-bit RGB recording format, such as JPEG, you are in a sense limiting the information-gathering ability of the sensor. If you work with higher bit-depth Raw, you'll gather more tonal, color and overall light information,

helping to expand the dynamic range somewhat. The more information you record the more leeway you have in creating the final image.

The extent to which you use image processing in the camera also has an influence on dynamic range. If you work in Raw you have virtually no processing aside from analog to digital conversion and the attachment of some instruction sets, mathematical formulae that accompany the image as it travels from camera to computer. In JPEG

and TIFF the image processing itself may further compress the dynamic range, especially so in JPEG. If you work with contrast and brightness overrides you also affect the dynamic range.

The image processor itself can have a profound effect on dynamic range. Some do a better job than others, as becomes apparent when you compare the same image made with an inexpensive point and shoot camera using JPEG and a digital SLR shot with Raw, or even compare JPEG to JPEG in different camera systems. Poor image processing can yield harsh and oversharpened images.

Exposure Latitude

The ability of a CCD or CMOS sensor to record a range of values brings up the issue of exposure latitude, the degree of over- and underexposure in which a usable image can be recorded. This does not mean that images of equal quality will be delivered throughout this range; it indicates the limits of tolerance of the media to underexposure and overexposure.

With digital media, you have the opportunity to fix exposure problems with editing software, but to do so requires that you spend most of your time on fixes, not on creative enhancement. If you find that you spend lots of time correcting for poor exposure then rethink how you expose and check your metering procedures. The best quality results from making proper exposure, one that bring as much of the values of the scene into play as possible.

In film photography, negative films are generally thought to be able to have an exposure latitude of five

The ability to retain detail in both bright light and shadow, as in this photo of a late-afternoon game, is a sign of a sensor and microprocessor that can deliver a wide Dynamic Range.

Even though you might pick up "noise" when you correct an underexposed image, you can still pull detail and color out of the scene. I purposely underexposed this image by about two stops and opened it up in the digital darkroom using basic contrast and brightness tools.

stops of light, with the distribution being three stops of overexposure (that is, three stops from the "correct" or averaged exposure) and two stops of underexposure. Slide films are much narrower in their tolerances, due to the reversal process to which they are subjected. That tolerance is about one stop of overexposure and one to two stops of underexposure.

Overexposure and Underexposure

The latitude of digital sensors is akin to that of slide films in that they do not handle overexposure well. When there is too much charge generated on the photo site due to an overexposure of, say, two stops, there is little or no useful information recorded. The site goes "blank" and the area of the image receiving too much exposure will look burned up, with little or no color or tonal information. Overexposure cannot easily be solved in an image-editing program. Gross overexposure seems

to wipe out, or interfere, with the signal, and once subject to such conditions the pixel seems incapable of recovering and delivering any usable image information.

Exposure latitude will vary somewhat depending on the file-recording format you choose. Shooting in Raw format expands the latitude of the sensor somewhat, and the greater amount of information seems to bring slight overexposure more under control. But this does not solve the overexposure problem completely, even though you can get about one more stop of overexposure latitude with Raw.

Digital sensors seem to have the same amount of underexposure latitude as negative film does—about two stops. Although noise may be generated because of underexposure, especially in the shadow areas, some tonal information is recorded, and detail can usually be brought out using Curves, Levels and other selective area tonal controls (see page 150).

Good exposure is a balancing act between all the light values in the scene. With overexposure (top), the cloud "washes out" and becomes harsh. This shot was made at plus-one exposure. "Normal" exposure (middle) yields both texture in the bright areas of the cloud and detail in the green trees and a good range overall. At one-stop under-exposure (bottom), the cloud is rendered well but the green trees become too dark and begin to lose detail in the shadows.

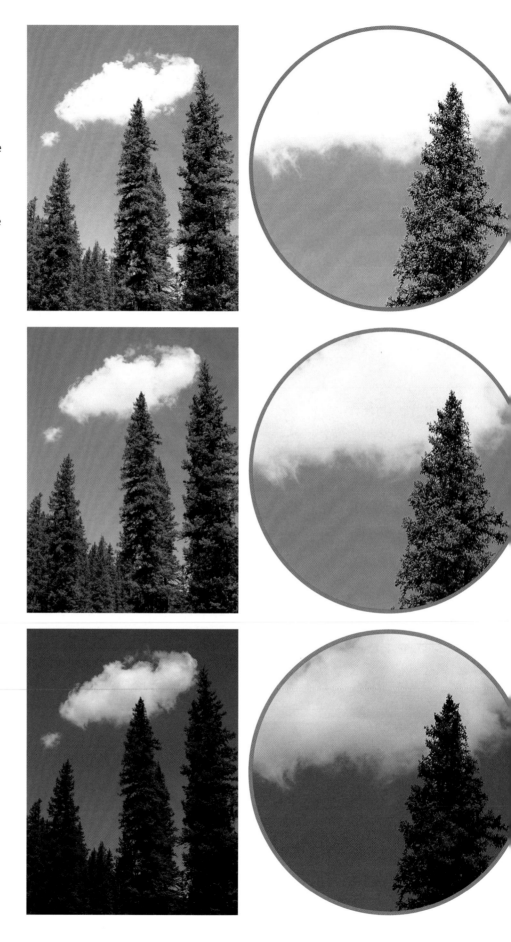

TWO EXPOSURE AIDS

The Histogram

When it comes to getting good exposures the Histogram is your true friend. A Histogram is a graphic representation of the exposure values in a scene. It tells you how exposure values are spread throughout the picture and whether any values have exceeded the recording ability of the sensor.

The Histogram works from shadow to highlight (dark to light) with the left side of the graph indicating shadow areas. In a scene with a good range of brightness values the tonal indicators should spread throughout the chart. If the scene is very bright, check that the graph does not bunch up entirely to the right; this indicates that you have to modify exposure to control the very bright values. And in a low light scene try to expose so the graph does not have all the values to the left.

In some cases the graph will have gaps across the spread. There is nothing wrong with this—it indicates that there was little or no brightness in those areas of the scene. Once you get good at reading and interpreting the Histogram you'll go a long way to making good exposures of every subject and scene. While spontaneous shooting might make checking the Histogram difficult, do take a moment to check it during your work. This can save you lots of trouble and time later and will cut down on the image-editing corrections you have to make in the computer.

To get a sense of how a Histogram works make exposures of various types of scenes in a range of lighting conditions, from "flat" to very high contrast lighting. Look at the spread of values and see where they might be lost (shown by the edges of the graph).

Many cameras with a Histogram feature also have a gamut representation, accessed by an option in the Info or Review menu. This shows overexposure by coloring in areas that are out of control. Some cameras also offer what might be termed a "live Histogram" display, which allows you to view the tonal spread before making an exposure. This can be immensely helpful as it allows you to adjust exposure controls as your work, a sort of interactive exposure meter that will vary as you change metering patterns or exposure overrides. (Some cameras also have "live" White Balance previews to show you the effect your White Balance setting has on the scene.)

The Neutral Gray Card

For those who shoot still life images, be they setups in the studio or the lilies in the field, putting a neutral gray card in the picture space can be a great aid in making image corrections later. In digital imaging the exposure you make in the camera can always be enhanced later in the computer. If you have a gray card in the scene it will be possible later to click on the gray point in the Curves or Levels controls and then click on the gray card in the image for a very quick fix. You can also make exposure readings from the neutral gray card (also called 18 percent gray, although in truth the reflectance is about 13 percent) as long as you place the card in the same light that is falling upon the subject. This is not always practical or possible, but it is a reliable way to get very good exposure readings.

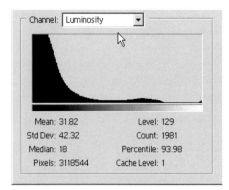

Mean: 31.82	Level: 129
Std Dev: 42.32	Count: 1981
Median: 18	Percentile: 93.98
Pixels: 3118544	Cache Level: 1

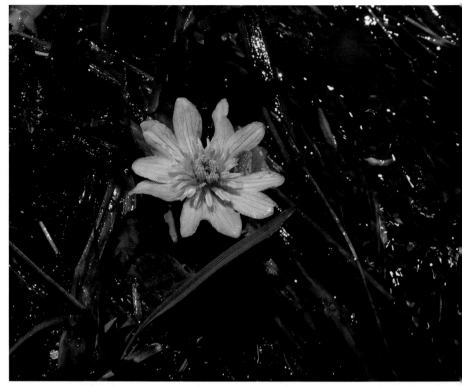

In the Histogram of this slightly underexposed image, note how the right side (the highlights) is almost flat, and the shadow areas clump up against the left side—this gives you a visual graph of the tonal spread in the scene.

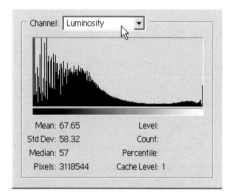

Mean: 67.65	Level:
Std Dev: 58.32	Count:
Median: 57	Percentile:
Pixels: 3118544	Cache Level: 1

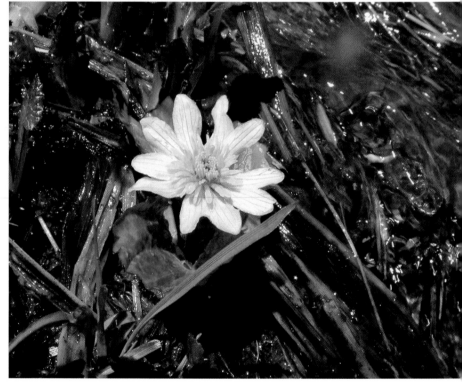

Levels controls in imaging software allow you to spread the values out, resulting in the brighter, more tonally rich rendition. The Histogram of this image shows how the values become more evenly spread.

Contrast

Although your digital camera will deliver good exposures under most lighting conditions you'll find that the biggest problem occurs with high contrast scenes. As discussed, overexposure of more than a stop can cause harsh highlights. If you are photographing in bright sun with a wide range of brightness values you have to pay close attention to the highlights.

Highlights and Shadows

The best way to get consistently good exposures is to learn the difference between how your eye "sees" and handles contrast and how the sensor "sees" and records brightness values. In photography the important values that define this contrast range are those in which you want to record textural detail and tonal values.

High-contrast scenes, where the difference between light and dark areas is severe, cause the most problems for digital photographers. But you're able to fix many problems in image-editing programs. This black-and-white image shows a high degree of contrast that I corrected somewhat in the digital darkroom by lightening the large rock and darkening the sand.

For example, if you photograph a white car in bright light, you might want texture and tonal value in the car body and details and perhaps even in the tire tread. But you might not care about the details in the asphalt in the shadow of the car. Or, if you're taking a portrait in bright light (not always the best idea) you'll want good skin tone values in your subject but may not care about information (details) in the shadow he or she casts. So, when you think about contrast consider the important parts of the scene first, then look at the background and other areas within the frame. You job is to get texture in the highlights and detail in the shadows.

Study light and practice looking at these values. Consider how each type of subject and scene changes the balance. For discussion's sake we'll call the highlight with

There are times when you might want to use dark shadows to make an expressive image and not worry about full detail throughout the brightness range. In that case you can read for the highlight area and allow the shadows to fall where they may.

texture the "significant highlight" and the shadow with detail the "significant shadow."

How you "place" or read the significant shadow and highlight will have a profound influence on the rest of the tonal values and image detail in the recorded scene. If you take an exposure reading of *just* the significant highlight you are placing that highlight on the middle of the recording scale—in essence, you are telling the exposure system that you want the highlight to record darker than it appears in the scene. If you make a reading of *only* the significant shadow it may cause the brighter areas to "burn up" and become overexposed.

See Like the Sensor

To manage scene contrast you should practice "seeing" like the sensor and make tests to learn how the sensor behaves under various lighting conditions. You soon discover that the sensor sees quite differently than the way your eyes see.

When you look around your eye is constantly adjusting to bright and dark brightness areas. Your visual system processes information so quickly that it adjusts for all these changes. The sensor does not do this, but the moment you snap the shutter you are "fixing" a certain range of brightness on the sensor; whatever information the metering system has at that precise moment is what the exposure will be.

There are two things to keep in mind when making the translation from what you see to how the sensor sees. One is that the sensor (and film) sees and records in a range of brightness values that are narrower than those in which you see. It is always compressing values and trying to manage the contrast differentials. The second is that your chief concern has to be very bright areas. Keep in mind that very bright areas might not record the way you want them to appear later. In fact, even highlights you might consider "normal" for your eyes can cause problems in a digital image.

Low Contrast Lighting

Flat, or low contrast, light is defined as ambient light with little or no contrast differential throughout the scene. With film, low contrast can result in rather dull images and the classic response is to increase developing time to increase image contrast, known as "pushing" or extending the time film sits in the developer. For digital, flat light is no problem, as it is quite simple to alter image contrast for each frame at the time of exposure or later, when the image is processed further in the computer.

Shadows and light create form, mood and give a dimensional feel to images. By making my light reading on the highly reflective rock surface, I created deep shadows and turned a photograph of leaves and rock into an abstract form.

QUICK CHECK FOR HIGHLIGHTS AND SHADOWS

Set up your bracketing sequence at plus-one EV and take three pictures of a brightly lit scene with shadows and highlights. One exposure will, in effect, average the two values, one will bias exposure for the highlights, and one will bias for the shadows. You'll see how light values are recorded and see the relationship between exposure and image quality.

This exposure of the Rio Grande Valley lost detail in the shadows. Using Layers and Layer Masks (see pages 144–146) I opened up the shadow areas to reveal more details without losing information or "texture" in the brighter highlight areas.

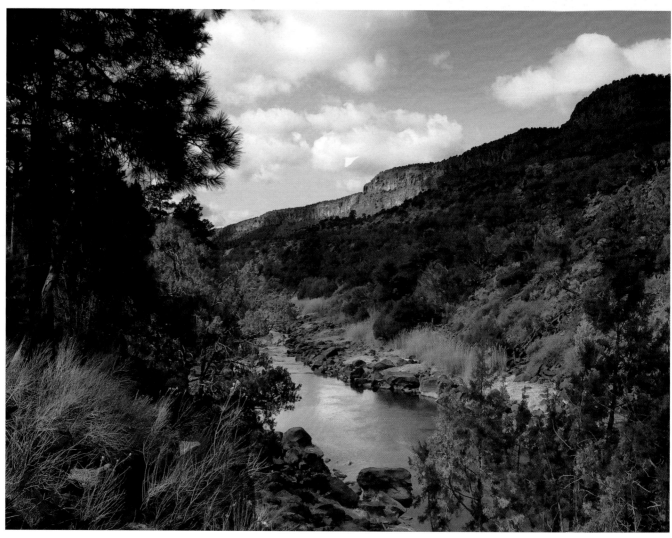

If an area of the scene is very overexposed you might not be able to make a good correction. This very high contrast scene shows very deep shadows and a very bright highlight area. I did not bias this exposure toward the highlight and the pixels literally "burned up" in the record. In the digital darkroom I opened up the shadows and tried to get better detail in the highlights but the gross overexposure caused odd color and noise.

Metering

The metering system on your digital camera provides several options for making readings in various types of lighting conditions. Probably the most useful will be what is often known as Evaluative Metering (though it may go under a different name in your digital system). This multipattern system reads light from every area within the image you have framed and makes calculations based upon pre-programmed solutions to the light problem it is presented.

Evaluative systems, for instance, can handle the classic exposure problem known as backlighting. This is where the light from behind your subject is bright, causing the main subject to fall within its own shadow. Evaluative systems read the light from the entire scene, "see" a large subject in the foreground and bright light behind it, do the microprocessor equivalent of an "aha" and conclude that this indeed is a backlit scene. The processor then attempts to compensate exposure so the foreground subject receives more exposure. Of course, this process may overexpose the background areas, but at least the important subject is well exposed.

Bright, reflective white subjects can cause exposure problems, but if you read the light correctly you should be able to record every bit of light value the scene affords. With the addition of one stop of Exposure Compensation, the white retains texture while the deep shadow area under the roof is also in view.

You can also arrive at a good exposure for the backlit scene using Center-weighted Averaging (CWA) Metering or Spot Metering, but both require more work and time than the evaluative system does. Another solution, and the one that will perhaps gives you the best exposure, is to use flash with the evaluative metering system. If the subject is in bright daylight and falls in its own shadow, then you can turn on the flash and it will illuminate the subject while the metering system, being smart, will also give you enough exposure for the background. Some systems even allow you to moderate the flash exposure through something called Flash Exposure Compensation (also called Daylight Fill Flash), which dims the output of the flash by varying degrees and gives a more natural look to subjects.

If the subject is in a dark room or outdoors at night you can use something called Slow Sync, sometimes called Night Scene Portrait exposure mode. This illuminates the foreground subject, keeps the shutter open to allow more light in, and eliminates the dark tunnel effect that can occur when using plain flash only as the exposure.

You can change the mood of any photograph just by the way you meter the light, and when you photograph you should try different ways of metering and compensating exposure to yield variations from which you can choose. This photograph displays a good range of values, but a variation in which I made readings from the rock rather than the overall scene is also interesting.

Picture Modes

These are sometimes called Pic modes, Scene modes or some sort of similar name and are essentially Program modes that can be applied to specific scenes or lighting conditions. You can use these modes as shortcuts to settings, but be aware that they are generalized solutions to exposure problems and may not yield just the right combination of aperture and shutter speed for the image effects you desire. As you learn more about how to create and craft your pictures you'll probably use Picture modes sparingly. Pro-level digital cameras may even dispense with these modes entirely.

Keep in mind that Picture modes may not always be able to deliver the desired effect due to lighting conditions or the type of lens you have on your camera. For example, say you select Sports mode, which favors a faster shutter speed over a narrower aperture. If the light is low the program will only be able to choose a shutter speed within the limits of the ISO you have set on your camera. In essence, just because you choose Sports mode doesn't mean you'll get a fast enough shutter speed to capture sports action.

In the chart below are some typical Picture modes and what they produce.

TYPICAL MODES

Picture Mode	Settings	Effect
Sports/Action	Favors faster shutter speed	To steady telephoto lens or freeze action
Landscape	Favors narrower aperture	To increase Depth of Field
Close-Up	Favors faster shutter speed	To keep picture steady
Portrait	Favors wide aperture	To make background unsharp
Night Scene	Flash and long exposure time	Foreground subject illumination with flash; background records with more natural effect

You can use the camera's Picture modes (sometimes called Scene modes) to match certain subjects and scenes with Autoexposure programs. Sports mode (top left) balances the exposure for the fastest shutter speed the camera will allow; if you want to get the fastest shutter speed possible raise the camera's ISO. Landscape mode (top right) employs the narrowest possible aperture for sharpness near to far. Portrait mode (lower left) might combine closest subject focus priority with a fast shutter speed, resulting in a narrow depth of field due to the wider aperture opening. Macro or Close-Up mode (lower right) changes the focusing range of the lens to close-up, defeats the flash and usually favors a fast shutter speed to help keep the picture steady.

Handheld Meters

The metering system in your camera is an amazing instrument capable of getting you very good exposures under a wide range of lighting conditions. This would seem to make the use of handheld meters obsolete, and, in truth, in large part it does. The main reason for using a handheld is to make very precise flash readings in the studio or the field. Handhelds can also be useful for making very accurate ambient (available) light readings. Using a handheld can eliminate the need to make exposure compensations or use other exposure overrides, as it reads the light falling on the subject rather than reflected from the subject.

There are three types of hand held meters, although the three uses are often combined into one meter these days.

- The incident light meter, recognizable by its frosted hemisphere or dome, should be used from subject position pointed back at the camera position. It reads the light falling on the subject and eliminates in-camera metering problems caused by reflectance and overly light or dark subjects and even problems caused by backlighting. This type of meter helps you "follow the light onto the subject," one of the tenets of making good exposure readings, and also eliminates metering errors caused by highly reflective objects, which can cause in-camera meters to underexpose the overall scene. It will also eliminate the need to make exposure compensation for bright dominant subjects such as snow-covered fields or white walls in sunlight.

- Spot meters read from a very select part of the scene and can be used to make readings from a select highlight or shadow value. This technique is useful for those who understand how to manipulate tones, but since most cameras already provide this function, it is not really useful to equip yourself with another handheld spot meter.

- Flash meters are used at the subject position and are pointed back toward the camera. They are very useful for still life or portrait work.

If you think you might benefit from using a handheld meter you should test the readings you get against results. You might find that the meter is a great aid to making good exposures or, possibly, that it is just another piece of gear you simply don't need.

A PRACTICAL EXPOSURE TEST

An excellent way to explore exposure options is to make tests that help you to get to know your camera and how it reacts to various types of lighting conditions. In truth, the sensor is only part of the story; the on-board image processor and how it handles lighting values also comes into the mix.

Take your camera out in low light, in midday bright sunlight, at night, and set it to evaluative metering. This is usually the default metering option on your camera. Don't do anything special with the exposure overrides or options and just point and shoot at different subjects in different types of lighting. Shoot scenes under the shade of a tree or building, inside rooms lit by window light, outdoors in bright, high light and at night with and without flash. When you review your images you'll immediately see how the camera systems have performed.

Are subjects in the shade well exposed? Does the flash "burn up" subjects close at hand? When you shoot in fairly high contrast do the highlights record harshly? When you use Fill Flash is the balance between background and foreground pleasing, or artificial looking? All these tests will help you understand your camera and how it performs, and will be very revealing about just how "smart" the metering system might be. In truth, not every digital camera reacts the same and not every metering system is as accurate as we might like.

If all is well you can go on making pictures and not worry too much about metering and exposure. If, as might be suspected, there are some less than pleasing results in some lighting conditions, you should understand more about your exposure options.

Familiarity with your camera and its "behavior" only comes with testing and experience. The slow shutter response of a basic digital camera caused me to miss this shot; the lapse between the time you press the shutter button and the exposure is actually made is called "shutter lag."

A digital SLR maker advertises a camera with a metering system that can make all sorts of calculations to overcome common exposure errors, but the claim, at least in this instance, didn't pan out; the camera meter gave a reading that caused this white hull to record as gray. A plus-one Exposure Compensation yielded the correct exposure. Learning how your camera reads light is key to making good pictures.

Dealing with Highlights

If you notice that highlights "burn up" in brightly lit scenes you will want to follow an exposure technique known as "biasing exposure for the highlights." If you have worked with slide film in the past you know the procedure. Basically it means that you use your metering system and its overrides to get those bright areas under control. You will use this technique in very bright conditions, when there are deep shadows and a mix of bright light and deep shadows.

There are two methods for dealing with highlight control. The general and easiest approach is to point your camera at a mix of the bright areas and the darker portions of the scene (not the picture you eventually want)

and to observe the exposure readings. Then move the camera to the framing you want and observe whether or not those readings change. If, for example, when you point the camera at the area that includes the brightest areas you get a reading of f/16 at 1/125 second and when you move it to the framing you want you get f/5.6 at 1/125 second, you know that there will be an imbalance of exposure and the potential for poorly recorded highlights. You'll often see this situation when the sky is very bright and the ground is quite a bit darker, and you want to include both in the framing.

The solution is to use the AEL (autoexposure lock) button on the first framing and then keep it set for the final

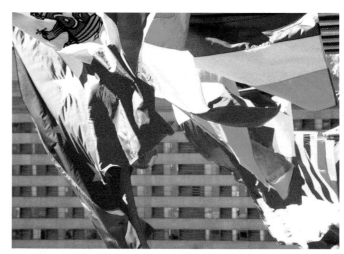

When the light is bright, be careful of burned-up highlights, such as those on the flags. Using spot metering and the autoexposure lock function, I solved the bright highlight problem.

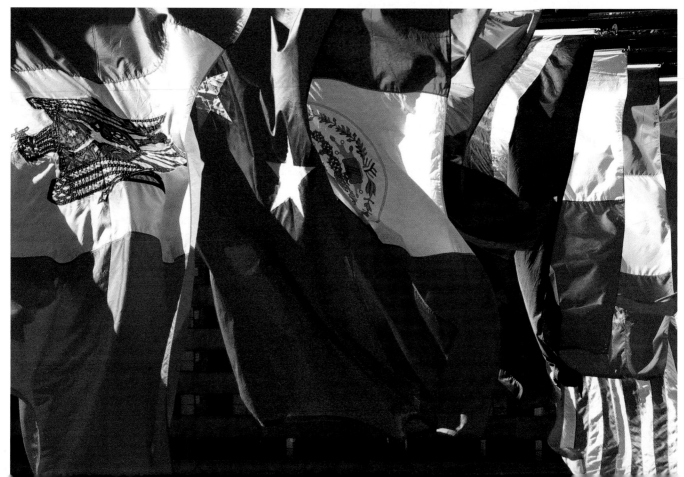

shot when you switch composition. This will ensure that highlights stay within range.

The second and more demanding approach is to switch to spot or CWA metering, point the camera at the brightest area in the scene, and use plus-one exposure compensation. This method first reads the highlight and places it at the center of the recording scale, and then in essence you move it "up" (allows more light in) to yield a more balanced exposure. Try these two methods to see which works best for you.

The exposure compensation approach is also a good solution when shooting scenes in which there is a very bright area, such as a snow-covered field on a sunny day.

The approach compensates for the fact that the metering system places whatever it reads in the middle of the recording scale. Failure to use exposure compensation might result in loss of details in darker areas and "gray" snow in the original recording. You can fix the brighter part of the scene easily enough later in your image-editing program, but if the darker areas do not record properly they will not yield enough detail to be fixed.

Follow the Light

Say you have a subject lit with window light. Should you read exposure from the subject or the window? If you are make a reading of the entire scene there is a danger that

A "straight" shot without any compensation or metering fix resulted in a burnt-up sky. The easy solution was to aim the camera at the sky and take a reading, lock exposure, recompose and shoot.

the bright light will overwhelm the meter and the darker main subject will be underexposed. If you meter for the window the subject will become even more underexposed. The key here, as it is with many types of metering situations, is to follow the light and meter where it falls. A good rule of thumb is to avoid making readings of light sources in any scene, except of course if the subject is neon lights and you want rich colors in the lights themselves.

If you are unsure of what to meter in a scene, remember the phrase: Follow the light and meter where it falls. In our window picture this means taking a meter reading off the subject where the light falls on it, using the AEL (auto exposure lock) to make the reading, then recomposing. Alternately, you can switch to manual exposure mode and make the readings, which will not change when you recompose.

In a landscape dotted with clouds, follow the shafts of light and read where they hit the ground, not the darker areas between them or the brightest area in the sky. In a street scene at night, keep the light sources completely out of the frame when you meter, lock your reading, and recompose as you will. Following the light, metering for the important subject, and watching out for bright highlights are rules that will get you good readings most of the time.

A uniquely digital approach that can handle any exposure situation is to make two recordings of the same scene (assuming the camera is fixed on a tripod)—one for the shadows, and one for the highlights—and to combine them later in the computer. Use this approach only if absolutely necessary, as it requires a lot of work in the image-editing stage. But it can get you out of some jams and is fun to try.

Zone System for Digital

Some photographers who come to digital via film might be familiar with the Zone System. This is an exposure and development system for black-and-white photography that, when understood and followed properly, can yield incredible tonal range. It is also a way to identify and place various brightness values on film via exposure and then use developing techniques to enhance the tonality for beautifully rich negatives. Most important, the system offers a way to "previsualize" results when you make the exposure and choose a developing technique.

If you explore all the aspects of the Zone System you'll see that digital gives you a good way to put that knowledge into practice. Keep in mind that:

- The best advice is to expose the highlight at Zone VII or Zone VI—test to see which works best with your camera—and let the shadows fall where they may. Post-processing, or working the image in the computer software program later, does allow for a good deal of manipulation of contrast and tonal values. In addition, you can make tests to see if you should adjust your contrast controls in the camera.

- If you expose for the shadows and subtract two stops you might also get some good results, but you are not able to pull process later (due to that highlight problem) to make up for the effects of highlight exposure. The overall contrast in the scene will of course determine your best course.

- Use the Histogram to check tonal values or apply Tone Curves controls, if your camera allows you to do this.

In this carnival scene, I made a reading of the distant rides so the bright fluorescent light didn't throw off the meter and render the rest of the scene very dark.

When in doubt the best metering advice is to "follow the light;" that is, to meter off the subject illuminated by the light source rather than off the light source itself. If I'd made a general reading of this desert scene rather than from the rock, I would have overexposed the foreground and lost the textural and color mood of the image. Likewise, in the church photograph I metered off the mosaics on the wall to keep the interior from becoming dark.

Flash

Most digital camera systems offer dedicated through-the-lens flash metering, which means that the flash and exposure systems work in conjunction and can be manipulated with automatic ease. There are two types of flash you might use—the on-board, built-in flash and an auxiliary flash that mounts in the camera's hot shoe or connects via a cord to a flash sync terminal on the camera body. Both work with the classic Guide Number (GN) system as the basis for the exposure, where GN divided by distance equals the aperture for correct exposure. The GN is the best indication of how powerful the flash might be and the distance it can cover.

Most on-camera flash systems offer a low GN and their coverage can be quite limited. See your instruction book to determine the most you can get out of such flashes—if you get ten feet of coverage you're lucky. That coverage will vary according to the lens you have mounted on the camera and the ISO you have set. Lenses with wider maximum apertures (such as f/2 versus f/4) will maximize that coverage. If you have a variable aperture zoom, where the aperture narrows as you zoom to telephoto position, then your flash coverage will drop off as you zoom in. To raise distance coverage with ISO increase the speed as needed. In general, doubling the ISO will get you half again the distance coverage; for example, going from ISO 100 to ISO 200 will extend flash coverage from 10 to about 15 feet.

If you want to extend the flash coverage and speed recycling time (the time it takes to fully charge the flash) you should get an auxiliary model. These offer higher GNs and can extend your range to as much as 40 feet, or more. Not every digital camera will allow for mounting these flashes, although every digital SLR will.

Flash Exposure Concerns

The chief concerns with flash exposure are overexposure when working very close; the "tunnel" effect, in which a well-illuminated foreground subject seems to sit within a dark space with no image information; and the well-known "red-eye" effect.

Red Eye is a function of the way the flash is mounted on the camera. When flash is mounted too close to the lens it reflects directly from the back of the subject's eye. So called "red-eye reduction" mode emits a bright light or series of stroboscopic flashes in an (often futile) attempt to constrict the subject's pupil, thus cut down on the effect. This does not always work well, or can cause the subject to look away after the initial light burst. The only cure is to raise the lights to help constrict the pupil or to have the subject look slightly away from the camera—not very good solutions. In most cases you will have to remove red eye later in the computer.

Overexposure can occur when you photograph very close and the automatic flash exposure system is unable to quench the flash output enough to make for a good exposure. This is where flash compensation control comes into play. Not every flash and/or camera system

CAMERA SHAKE

Some cameras have an Autoflash function that will fire the flash whenever the exposure system concludes that shooting in the lighting conditions at hand will result in camera shake because of a slow shutter speed. You can "defeat" the flash or the tendency for these systems to turn on the flash by going to the Flash Off mode. This is necessary when photographing in areas where flash is forbidden, when it might distract the subject or when flash is just not right for the subject or mood. Just keep in mind that the shutter speed will be slow and that you will have to steady the camera as best you can to avoid "shaky" pictures.

has this feature, which essentially "fools" the metering system into thinking that it has a higher ISO available and cuts down on the amount of the output. Experiment with your flash and flash compensation to see what works best.

Tunnel Effect occurs when the exposure system reads only the light reflected back from the subject you've illuminated with flash. This subject-only reading will necessarily darken the surrounding area and background, making the subject well lit but seeming as if it is in a dark void. There are two automatic-exposure solutions to this and you can choose one and/or the other depending on the type of flash exposure options your system affords. With both of these approaches, keep the camera as steady as possible.

- With Slow Sync, the shutter stays open longer than required to make the flash exposure. This brings in more light from the background and yields a more natural effect. You can set the Slow Sync shutter speed yourself (usually somewhere between 1/8 and 1/30 second) by working in Shutter Priority mode and setting the speed as necessary. Or, work with one of the camera's Picture modes (if available) known as Slow Sync or Night Portrait mode.

- Daylight Fill Flash (or Flash On) mode (see page 150) is a great way to solve backlit subject problems. Fill Flash can also come in handy for adding vividness to the color of subjects in the shade and when you need to fill shadows in bright light.

Backlighting, where the light behind the subject is brighter than the light that falls on the subject, is one of the main causes of exposure problems. You can get around backlighting in the camera or later in your image-editing program. Bright light behind the statue and subject threw the meter off and caused the main subject to be underexposed—easily fixed in the digital darkroom, when I lightened the main subject and deepened the sky.

Using the camera's Autoexposure mode with the presence of such a large dark foreground caused the background to become too bright. So I metered for the brighter light using the camera's CWA metering pattern and lightened the darker parts of the scene later in the digital darkroom.

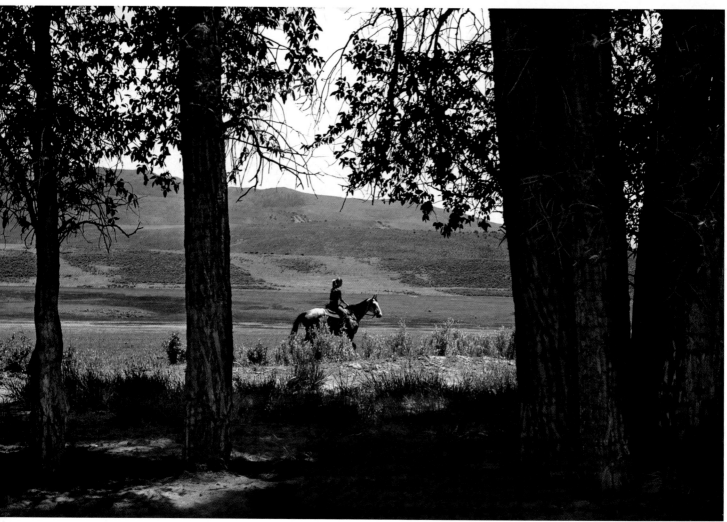

Slow Sync combines a slow shutter speed (for low light exposure) and flash. Slow shutter speed caused the spinning lights to blur into one line, but for the second shot I used the same shutter speed (1/4 second) and added flash. This gave the same motion effect and illuminated the people on the ride.

Lenses and Focusing

The Lens

Focusing Techniques

CONSIDER THE MANY FUNCTIONS OF THE LENS. The lens aids in exposure control via its aperture setting, focuses light onto the sensor, defines the angle of view, helps create image effects that change the Depth of Field and, with some models, even helps determine the distance from the camera to the subject being focused upon (an aid in getting excellent flash exposure). Little wonder that a little knowledge of the lens and how it works can improve your photography considerably.

A long telephoto lens compresses space and yields a narrow angle of view; these buildings and statues in Prague are actually hundreds of feet apart from one another.

The Lens

A lens is composed of individual glass elements that are joined together in groups. This array of glass and connectors is built into a barrel and joined to the camera via a mount. The mount is particular to a specific type and brand of camera body. The lens has a front and rear element, the front being where light enters and the rear where it exits. Inside the lens is a variable aperture, an opening whose diameter can be changed.

Your choice of focal length determines both the angle of view (how much of the scene the picture encompasses) and the effect created by the lens itself. Wide-angle lenses open up the picture space, and I enhanced this image of the grand sky in Glacier National Park by tilting a wide-angle lens so it captured the towering clouds.

The f-number, or Aperture Setting

An f-number or aperture setting is an indication of the actual diameter of the lens opening in relation to the focal length of the lens. Lenses offer a range of f-numbers that allow you to change both the amount of light passed through as well as the image effect called Depth of Field, a topic we'll cover shortly. That range can be from, say, f/2 to f/22, depending on the lens. The lower number

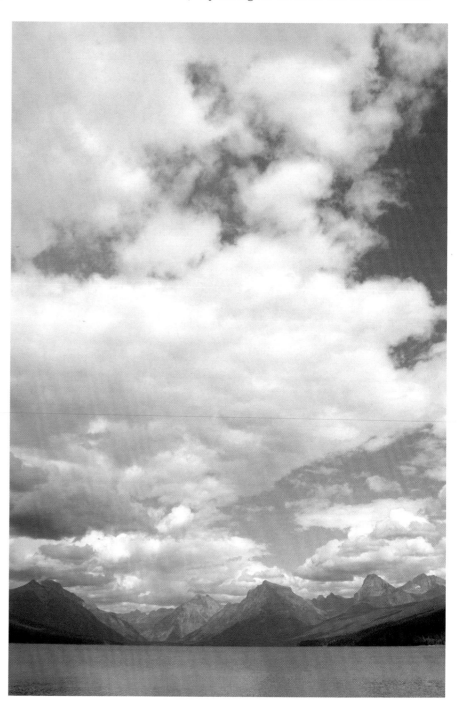

(f/2) indicates a wider opening. The widest opening available is called the "maximum aperture." The narrowest opening is called the "minimum aperture." A lens is said to be "fast" if it has a relatively wide maximum aperture, say f/2 as opposed to f/4.

The Aperture Range

A lens may display a range of apertures such as f/2.8, f/4, f/5.6, f/8, f/11 to f/16. The lens and camera may allow you to vary the aperture at any point or between any points within this range. When you move from one of the settings to another in the above range you are changing the exposure by one stop or exposure value (EV) and you are halving or doubling the amount of light that the lens allows to pass. Moving from f/2.8 to f/4, for example, allows in half the light, while moving in the opposite direction doubles the amount of light that passes. The same principle applies to shutter speeds, where going from 1/60 to 1/125 second allows in half the amount of light while going in the opposite direction doubles it. Changing shutter speed in this fashion also means a one stop or 1 EV change.

Because you can go up and down with equal measure in both aperture and shutter speed you can vary the two to get the same exposure, or amount of light reaching the sensor. This coordinated system is often called working with equivalent exposures. That's how different image effects (such as depiction of motion and Depth of Field) can be achieved with the same exposure.

The f-number always represents the same amount of light regardless of the lens in use. That's because that number is arrived at by calculating the diameter of the opening in relationship to the focal length of the lens. So, f/8 on an 80mm lens represents a 10mm opening in the lens while on a 24mm lens the opening is approximately 3mm wide. In practical terms this means that f/8 on any lens, and at every focal length, delivers the same amount of light.

Focal Length and Angle of View

The focal length of a lens determines the angle of view—what you see when you look through the viewfinder when you mount a particular lens. Think of angle of view as peripheral vision. A "normal" lens gives you about what you see from inside your head; a telephoto brings you closer to distant subjects and narrows the angle of view, while a wide-angle lens may expand your usual field of view. There are also super telephotos (for a very narrow angle of view, like looking through a narrow tube) and super wides that can show you vistas that you can only take in if you shift your eyes across a scene.

A 10X zoom shows off the power of a zoom to make compositional decisions without changing lenses or taking your eye from the viewfinder. These views show the widest and narrowest angles of view this lens offers. When working at high magnifications like these, keep the camera as steady as possible and, if the light allows it, use a fast shutter speed to avoid camera shake.

Angle of View and the Digital Factor

Most manufacturers quote angle of view as "equivalent" to what you would get with a 35mm camera. This is a comfort zone for most photographers who can readily associate the number with a certain angle of view, such as 20mm for super wide and 300mm for super telephoto, for example. Another reason for quoting equivalents is that with digital the relationship between angle of view and the focal length of the lens depends on the size of the sensor (in fact, just as it does with film formats as well.)

This factor occurs because of the way a lens transmits light. The light that exits the lens from the rear element does not do so in the form of a rectangle, the shape of the sensor (or film). It actually projects a circle of light that gets clipped at the corners by the frame.

If the sensor in your camera is the same size as a frame of 35mm film then there is no difference between the angle of view when you use the lens from your 35mm SLR on your digital SLR. But if that sensor is smaller (most are) then the proportion to which they are smaller will alter the "practical" focal length of the lens in use.

If the sensor is proportionally half the size of a 35mm frame then the difference will be 50 percent; thus a 50mm lens from a 35mm SLR will in actuality behave like a 100mm lens on a digital SLR. The multiplication factor might be smaller or larger, depending on sensor size. The aspect ratio of the sensor might also be different (the relationship of height to width as opposed to the aspect ratio of 35mm film) and this also comes into play.

Sensor sizes and aspect ratios vary so there is no hard-and-fast rule about equivalent focal lengths. For example, a digital camera with a very powerful zoom lens might have a 4.6–55.2mm zoom lens. To a 35mm shooter this seems impossible, as that's wider than any lens available. But the translation in "digital focal length" might be 35–420mm, a factor of about 8 when making focal length conversions. This is quite high and indicates a fairly small sensor size. A camera with a 7.2–28.8mm lens might translate to a 34–140mm zoom, indicating a larger sensor. And one that is equivalent to a 100mm lens when a 50mm lens is mounted is a larger sensor still.

That's why manufacturers quote 35mm equivalents; the sensor size and shape make all the difference in the world. What you need to know is the angle of view. This could be quoted as angle of view but it seems that manufacturers have decided that the 35mm equivalent better describes the lens capabilities.

This factoring is one reason why digital photographers, aside from those who have a "full frame" (read 35mm size) sensor, are often hard pressed to utilize super-wide angle photography with digital SLRs. Let's say a photographer wants to go very wide and uses an 18mm lens from his or her film SLR kit. Some digital SLRs with smaller than full-frame sensors would convert this to nearly a 28mm equivalent, somewhat wide but not anywhere near the effect of an 18mm focal length.

In addition, because of the angle at which light from the edges of the super wide would hit the sensor there could be a problem of light falloff at the edges of the image, an effect known as vignetting. Some cameras handle this better than others, and as we progress this super-wide "problem" will be better solved. One way to gain a wider field of view is to use wide-angle adapters sold for some digital cameras. These do yield a wider view but these add-on lenses rarely deliver the kind of optical quality obtained from a "prime" lens.

"Steady" Lenses

A fairly recent development in lens technology is the so-called "vibration reduction" or "image stabilization" lens. These lenses work with sophisticated light paths that actually help you achieve more stable images with slower

As you zoom in you begin to narrow the view and get closer to your subject. I made the first three images with a 10X zoom lens, but for the shot at the lower right I used a "digital zoom" that makes for a 30X magnification. Digital zoom is quite different from optical zoom in that it cuts down on the area of the sensor used to record the image, in essence cropping into the longest focal-length range framing. Use digital zoom only when absolutely necessary, as it generally results in an image that lacks sharpness and detail.

than usual shutter speeds. One maxim for working with lenses is that to get a steady picture when shooting hand-held you should use a shutter speed that is 1/focal length of the lens. For example, when working with a 100mm lens the shutter speed should be 1/125 second and with a 300mm at least 1/250 second. These figures will vary according to how steady you can hold the camera. Of course, with digital you can raise the ISO for faster shutter speeds on every frame. This helps the situation somewhat, as every stop you gain in sensitivity can be applied to using a faster shutter speed.

In any case, these "steady" lenses actually allow you to photograph with shutter speeds two to three stops slower than "normal," and give you a lot more leeway in the type of light in which you can use a particular focal length. This really comes in handy when using zoom lenses with fairly narrow maximum apertures, such as f/4 or f/5.6. For example, let's say you're working with an ISO of 100 with a 300mm lens in fairly dim light and the best reading you can get with this maximum aperture f/4 lens is 1/60 second. You could boost the ISO but you might hesitate to do so for fear of losing some image quality.

With the steady lens feature activated you can pick up two stops so you can photograph at f/4 at 1/250 second (a much better option) or even "spend" the pickup in stops on aperture to f/8 to attain deeper Depth of Field.

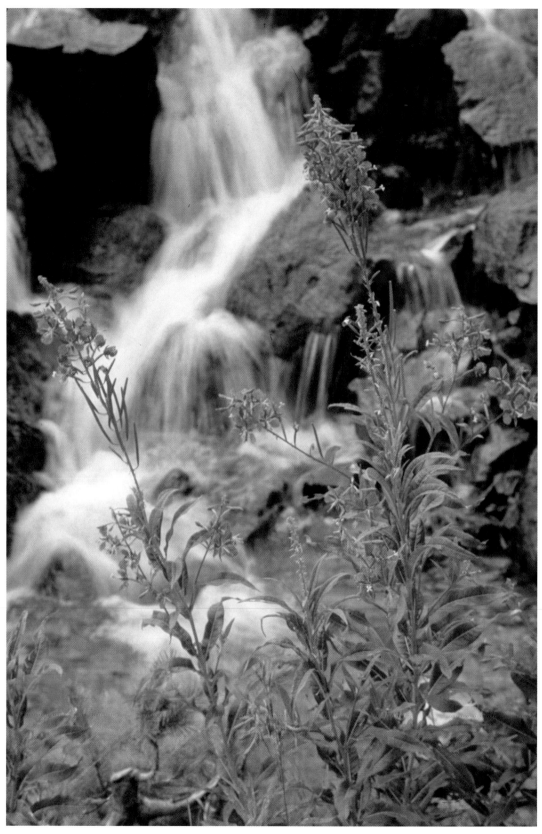

Another specialty lens is one that features "image stabilization" or "vibration reduction." Using special optics the lens allows you to photograph at "hand-holdable" shutter speeds much slower than if you used a lens without this feature. I made this rendition of flowing water handheld at 1/8 second with a VR lens.

Focusing Techniques

Every digital camera sold today has an autofocusing system. You can use most of the systems as manual focusing cameras as well, but autofocus (AF) works so well that there is usually no need to go manual. The only time to "go manual" is when the lens cannot find focus, usually caused by lack of contrast in a scene such as a blank or monochrome sky. Autofocus works with targets. The camera's default target is usually dead center in the viewfinder, with some having wider-focusing targets than others. In most cases the system will focus on the closet subject within the target area.

This simplified approach has been made more sophisticated, and perhaps more complicated, by the addition of additional focusing targets in the viewfinder. These multiple targets may be arranged in a cross pattern or as a cluster of boxes. You can select one or a group of targets using one of the command dials on the camera body. Once you have selected you can also choose to have the target or targets light up to indicate where focus is being obtained, and observe the AF confirmation light in the finder to ensure that focus has been achieved. In addition, some cameras have features that will follow the subject once you have selected focus on it to other areas within the frame, a great aid in action and sports photography. This "predictive," "dynamic" or "follow" focus is amazingly smart.

Focusing Modes

Aside from manual focus, there are two focusing modes available on most cameras. Single Mode locks focus on the target and will not allow you to release the shutter unless it has found focus; use this when working with stationary objects. Continuous Mode does the best it can to

This simulation of focusing targets shows how using focus target selection (or AF lock) can overcome autofocusing problems. (Top left) A default center target causes the camera to focus on the background, so the foreground is not clear. By using a simplified target setup (top right), you can change the target to the right-side focusing detector (lower left). As a result, the truck in the foreground is now sharp (lower right).

achieve focus but will allow you to make a picture even if focus has not been achieved; use this when you want to make an image of a moving object, whether the focus has been set or not. Choose single when you can and continuous only when necessary or when photographing a subject in motion.

For those cameras that do not have such elaborate focusing systems the subject "acquisition" is made in the center of the viewfinder frame. If the main subject is off-center in your composition you can use the Autofocus Lock (AFL). It's a simple operation; you press lightly on the shutter release button to activate focus, lock focus and then recompose. This technique can also be used with more complex systems.

Focusing and Exposure

Some metering systems cameras link the selected autofocus target with exposure so that the light from the target area determines the autoexposure setting. This makes sense most of the time as the subject you want in focus is usually the one where you want to expose correctly. You can unlink these two systems if you so desire using the Custom settings in the camera menu, if available. Another focusing/exposure feature is available with lenses that have a "D" identification in their branding. The "D" stands for distance, which means that the lens feeds back the set focusing distance to the exposure system. This is especially helpful when making flash exposures.

Depth of Field

Aside from light control, lens settings and focal length have an influence on one of the most creative effects in photography—control of sharpness in the image. Sharpness here does not refer to focus, although the subject on which the lens is focused is the starting point for most Depth of Field considerations. Using Depth of Field effects you can have a subject in focus and a blurred background or have sharpness from the subject to infinity, or anywhere in between.

Just as your eye constantly adjusts for varying brightness levels it also moves around focusing very rapidly on subjects at different distances. The lens cannot do this and actually just attains a point of focus at a set distance from the camera. But Depth of Field effects create the illusion of sharpness at a variety of distances from the camera, depending on how far you stand from the subject and the lens settings and focal length you use. The almost

surreal quality images that have completely blurred backgrounds, or that are sharp from one foot to infinity, are part of the magic of photography.

Depth of Field is determined by a number of factors: the focal length of the lens being used; the aperture setting; and the distance of the camera from the subject. Each factor can be varied for a nearly infinite number of sharpness effects.

Here's a breakdown of how each factor affects the Depth of Field in an image:

Factor	Greater DOF	Less DOF
Lens	Wide angle	Telephoto
Distance to Subject	Farther Away	Closer
Aperture	Narrower	Wider

Each of these factors can be mixed and matched. To attain the greatest potential Depth of Field with any subject and lens use the combination under Greater DOF (greater Depth of Field); to attain the narrowest Depth of Field use the combination under Less DOF. Each subject and scene will dictate what works best.

Close Focusing/Macro Photography

Some lenses offer a close focusing mode, which means that the lens can be used to make images of subjects very close to the camera. Macro photography is an exciting way to capture views that the unaided eye rarely sees. If you enjoy photographing flowers, insects and tiny forms and patterns you will enjoy using a specialty macro lens.

In some cases you will have to manually shift the lens or, with integral lens cameras, use a menu option to work in this range. Keep in mind, too, that when you make this shift you might not be able to focus the lens at "normal" ranges until you get out of Macro mode.

Digital SLR users might opt to work with special lenses that are constructed to perform best at close ranges, or that have special optical systems that enhance the close focusing performance. This is often stated as a "reproduction ratio" (RR). This ratio might be 1:2, or even 1:1, meaning you can get as close as half life size or life size, respectively. The closer you get to a 1:1 ratio the closer you can focus on your subject. With digital cameras that do not link the viewing eyepiece to the lens (integral lens or point and shoot digital cameras) you have to view, focus and compose through the LCD. Digital SLRs give you a direct view of what is being recorded.

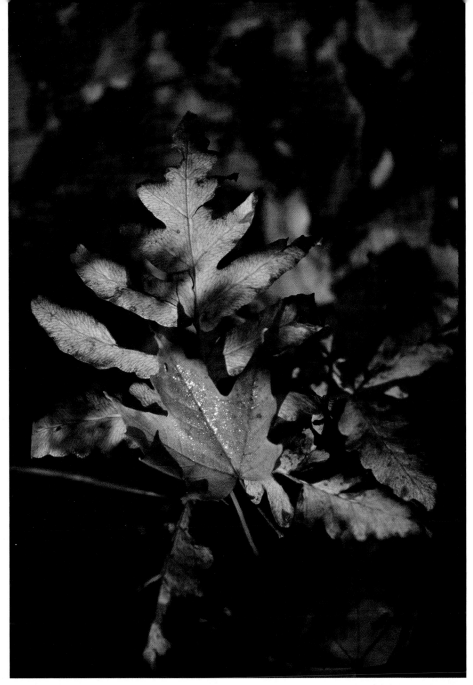

Depth of Field techniques allow you to control what is sharp and not sharp throughout the depth of the picture "space." Using wide and narrow apertures, different focal length settings and camera-to-subject distance you can control depth of field to yield a wide variety of image effects. I made this photo of fall leaves from a close point of view using a telephoto lens setting, a wide-open aperture and a close point of view. In this photo of a memorial service for the victims of September 11, I used a wide-angle lens set at the narrowest aperture possible and a deep depth of field to bring the bell and the participants into focus.

From Camera to Computer

Memory Cards

Downloading

Storage

Image Editing

ONCE YOU'VE MADE AN IMAGE WITH YOUR DIGITAL camera, the raw data goes to an image processor (or buffer, where it awaits processing) and to a digital converter, where all the components are integrated. The information then goes to a storage device called a memory card—a place of temporary transit, from which you will download the data to image-editing software.

A digital photograph can be a starting point for experimentation and play that can lead in many directions. Because the image is composed of pixels with "addresses" that can be changed or altered, almost any interpretation is possible. This photograph of a wall and part of a truck was colorful in its own right. Working with imaging software (from top to bottom of insets) I increased the color saturation; replaced and posterized colors; and made a conversion to a line drawing effect. Knowing your creative options is one of the keys to getting the most enjoyment from your work.

Memory Cards

A memory card is a solid state or drive device (in the case of the MicroDrive) that, in the way it is used, is just like any other information storage device, such as the floppy disk or CD-ROM. The card is rewritable, which means information can be erased and written on it many times. Unlike film, it can pass through airport security devices without harm.

Memory Card Formats

There are more than half a dozen formats, or sizes, of memory cards, including CompactFlash Type I and Type II, as well as the MicroDrive, SmartMedia (found in older cameras and slowly fading away), MMC, SD, xD, mini CD and MemoryStick. The camera you use dictates the format you use, and some cameras take more than one type of card. Looking ahead, as sensors climb in their pixel count, cards that can hold larger amounts of information will become more prevalent.

Card Capacity

Memory cards are made with various amounts of storage capacity, which is defined in megabytes or gigabytes. Cards are sold in 16, 32, 64, 128, 256 and 528 MB and 1 to 4 GB, with higher capacities on the horizon. The price of the card is tied to its storage capacity. It makes little sense to use lower-storage-capacity cards, as even a 64 MB card can only hold about four shots made with a 6-megapixel sensor camera. If you have a digital SLR with a 6-megapixel sensor, each high-resolution uncompressed TIFF image will be recorded at about 18 MB per shot, so you can see how quickly you will fill up a memory card. (You can store more shots on a card if you use JPEG compression.)

DO YOU NEED A WRITE-ACCELERATED CARD?

Do this simple test. Make the largest image file size you can at as many frames per second your camera can deliver in Continuous Shooting mode. Use a "regular" card and a write-accelerated one. The slower card will slow down the rate at which you can work and might, in some instances, get in the way of making the kind of images you need to get. If you find that you need a write-accelerated type then make the investment; if not, then more common cards are fine for use. Note: Using an excelerated card in a camera that cannot read or write at that speed will be of no advantage. Check your camera speed.

Memory cards come in many and varied formats. One of the smallest is the XD card. Photo: Courtesy Olympus America

As you photograph you can watch a card fill up by following the "countdown" or "pictures remaining" number on your camera's LED. The image processor is constantly calculating its remaining capacity depending on how you format each image, so as you change your image file format and compression that number can move up or down. For example, switching from an uncompressed TIFF format to a 1:4 JPEG format will increase the number of images that can still be recorded on the card.

Write Speed

A card also has a certain "write" and "read" speed, the time it takes to receive the information it is being sent and to download the image information. The write speed is dependent on how fast the camera's image processor can handle the tasks of integrating and converting the image. Write speed, in turn, will affect your framing rate, or how many images per second you can make. This is all tied together with the buffer capacity and the transfer rate. In short, if you have a camera that has a speedy processor, or one that processes in parallel rather than serial (one pixel at a time) your images will be written to the card faster.

Some cards are dubbed "write accelerated," which means they can actually receive information faster than others can. If the type of photography you do requires fast framing rates (if you shoot sporting or news events, for instance) then it would be a good idea to make sure that your camera has a fast processor and that your cards are write-accelerated to be able to handle the flow.

You will also find that the write-accelerated cards help to transfer information faster when you download. But again, that speed is highly dependent on your receiving and transfer system. If you have a slower card reader and use USB 1 as opposed to USB 2 or FireWire then even faster speed cards will show little or no improvement over regular cards.

HOW MUCH WILL YOUR MEMORY CARD HOLD?

The number of images your memory card can hold depends on two factors—the capacity of the card itself and the size of the images you record on it. Use JPEG compressed images and you'll get more on the card. Shoot TIFF or Raw and you'll get less. You can observe the "countdown" on capacity as you shoot. If you mix recording formats the capacity counter will go up or down depending on the recording format you use.

To see how image size and format affect capacity, here's a chart that shows the number of images per card using a 2560 x 1920 image resolution if you were to shoot with one type of file format. Of course, much higher capacity cards are available, so use this chart to get an idea of how format and compression affect image capacity in general.

As the ability of the sensor to deliver larger file sizes grows so has the capacity of the available memory cards. This 4 GB card can hold thousands of compressed JPEG files and hundreds of noncompressed TIFF files. These cards can also be used as storage areas of image albums.
Photo: Courtesy SanDisk

Card Capacity	16 MB	32 MB	64 MB	96 MB
TIFF	1	2	4	6
Raw	2	4	9	13
JPEG Fine (1:6)	7	12	25	38
JPEG Normal (1:12)	14	24	50	76
JPEG Basic (1:24)	28	48	100	152

Downloading

So, your card is full. What's the next step? You have some options. You can simply review your images and delete those that don't make the grade. Your Review mode allows you to access a delete or trash button or key, usually a two-step procedure that confirms that you really want to dump the image. The best and safest method for clearing a card, though, is to download the card's contents to a hard drive or other storage device and clear it for the next round of picture taking.

Downloading to Storage

You have some options here, too, but however you download, remember to turn off your camera before removing or replacing a memory card. Failure to do so can result in corruption or loss of image files. Also, if you can, download with the camera's AC adapter connected, as losing battery power during downloading will halt and sometimes corrupt the process.

- Carry extra memory cards with you, and simply replace them as needed.

- Carry your laptop with you and use a card reader to download images right into your hard drive. Some laptops come with slots for various card formats, which the laptop "sees" as another peripheral drive. You can also buy adapters for common PCMCIA slots. You then just

The easiest way to transfer images made with a digital camera is with a card reader, which eliminates the need to patch the camera to the computer. Card readers that use FireWire or USB 2 (with a similar connection on your computer) offer very fast download times.
Photo: Courtesy SanDisk

CARD READERS

One of the most practical accessories you can buy for your digital photography is a card reader, which is essentially a portable drive that eliminates the need to hook your camera to your computer for downloading images. In fact, a card reader is the easiest and most convenient way to download images.

A card reader houses a single slot for a certain format card or multiple slots for many different types of cards. It attaches directly to your computer through a USB or FireWire patch. Most operating systems recognize a card reader as an external drive and it shows up as an icon under My Computer on PCs or as a drive on the Mac desktop. When you click on the icon or drive, the image Folders appear and you can drag and drop these into whichever Folder or location you desire.

Among their many other advantages, card readers:

- Eliminate the need to hook your camera to the computer every time you want to download.

- Are not camera-dedicated, so you can use them with any similar type memory card or cards from any number of cameras.

- Usually follow the Mass Storage Device protocol and computers recognize them as other drives, so there is no need to install additional software.

Dockable Cameras
Some point-and-shoot camera brands and models work with a docking system for battery charging and image downloading. These are like card readers in that there is no need to connect the camera itself. Instead, the dock itself is cabled to the computer; all you do is place the camera in the dock and press the download button. The images then travel from the card in the camera right into the computer software.

drag and drop the images from the card Folder to the receiving computer's drive.

• Download the images into a portable hard drive (also known as a card reader), a pocket-size device that can hold a surprising amount of information, with some coming in with 60 GB capacity. These portable hard drives usually require you to remove the card from the camera and place it into a slot in the device (see box, facing page). Many are built to take CompactFlash cards in their various versions, but most also offer adaptors for different card formats.

Once you have downloaded, open the Folder and/or Browser to confirm that the images have been successfully transferred before you wipe the card clean. Some download programs give you the option to erase the images from the card automatically once download is complete; never use this feature, as you should always confirm a successful download before erasing or reformatting. Sometimes, for example, a card is corrupted or there is a malfunction in the connection. If this occurs, you may be able to use photo recovery software to retrieve an image.

Once the download is complete and you have verified that a copy has been made you can either reformat the card or erase each image or group of images using your camera software.

RAW DOWNLOADS

If you are working with Raw file formats you can choose to download with a standard card reader into any Folder or by using the camera or third party Raw software. If you download with a card reader you will have to open and read the files with the Raw software, so it just saves a step to download into the Raw software so the files are already in that software's Folder. (See also page 49.)

Download Speed

The speed with which you can download depends on two factors—the write speed of the card and the type of connector you use. The old standard of USB 1.1 is being replaced by two preferred download connections that offer greater speed—USB 2 and FireWire. Most digital SLRs have at least a FireWire option. Of course your computer and card reader will need to be able to hook to these faster patches. If you have a USB 1 camera connector and a USB 2 port on your computer then you'll get USB 1 performance.

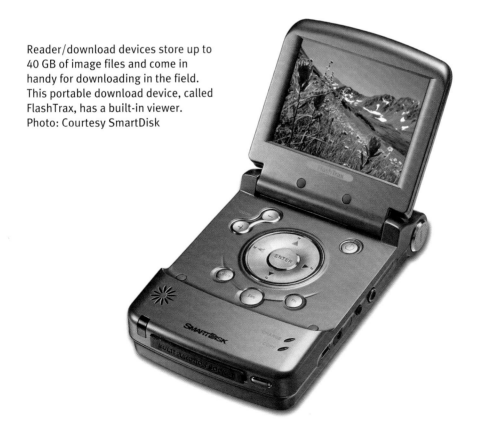

Reader/download devices store up to 40 GB of image files and come in handy for downloading in the field. This portable download device, called FlashTrax, has a built-in viewer. Photo: Courtesy SmartDisk

Storage

Once you have your downloaded images you should begin the process of sorting, deleting, saving and archiving them. This will help you find the images you want later. Unlike film images, where you have the original negative or slide, the images now reside in electronic form. That's why a good amount of housekeeping is necessary, as anything can happen to information on your computer. Once gone your precious images usually cannot be recovered. One important step to take is to always back up your images to protect them by burning a CD-ROM or DVD at least once a month.

Image Edits and Deletes

It's a good idea to make your image edits right away. Open your image organizing software and click on the Folder you just downloaded. This will open a Browser window in which thumbnails of the images in the Folder are displayed. Many programs will allow you to get a full screen image by double clicking on the thumbnail. Do so, because the full-screen image allows you to make a critical inspection of sharpness and exposure that you can't do with thumbnails. You will save an image automatically when you simply move on to the next image or you can

Once you have downloaded your images you can begin to sort, rename and delete images using Image Browser software. This Browser, from ACDSee, shows the hard drive directory and automatically shows the albums in the My Pictures folder.

This Browser window, from Picasa, shows all the Folders on your hard drive that contain images and allows you to scroll down through each without having to click on the directory. You can organize each image into subalbums and even identify individual or groups of images with keywords.

dump an image by using an "X" button in the Browser or by hitting the delete key. This may yield a prompt asking you if you are serious about dumping the image. Just confirm your decision and the image will head for the trash or Recycle Bin.

Using the Browser

Use the Browser/Organizer that comes with your computer or image-editing program to name, organize, store and make backup copies of your originals.

An image Browser is just like any file directory on your hard drive except that it displays images and not just file names. The Browser groups images into Folders (or, as some programs call them, Albums). You should name these Folders to help find images later just as you would a put a tag on a file Folder inside a filing cabinet. Some programs will name the Folders for you with either the date the images were downloaded or with a name assigned by the digital camera itself.

When you click on the Folder every image within that Folder will "load" onto the screen. The images appear as thumbnails with the file name and sometimes the format and file size underneath. Double clicking on that file opens the image to larger size on your screen. If you use a Browser inside image-editing software, double clicking might launch the image right into the software. Or, you can use image-organizing software to export the image to the editing program of your choice.

Once you click on an Album (or Folder) in ACDSee the entire contents appear on the screen. From there you can create an HTML page for web use, a slideshow for display or a contact sheet of the entire content.

Most organizing software packages allow you to link directly with an image-editing program. This Album software, from Adobe, opens Photoshop or Photoshop Elements when you click on an image.

Most Browsers handle JPEG, TIFF and other common image file formats, but some may not recognize Raw files or show and open them as TIFFs or JPEGs. Usually, the Raw software that comes with your camera will allow you to export the opened image right into your editing program after you do a "Save As" operation.

Organizing with the Browser

Once you have edited your images and deleted those you know you won't want to see again it's time to organize the remainder into Folders. You can name these Folders according to the date, to the subject, to an event or to a locale. You can also add comments, captions and keywords to each individual image file. Keywords are especially useful, because you can do a keyword search to find an image or group of images later.

The way you save them to the Folder depends on how your software or operating system works. Some allow you to drag and drop images right from the Browser into the new Folder you have named and saved. You can drag small groups of photos or entire sets. With many pro-

grams you can use the Shift key to define larger sets by clicking on the first and last of a series of images and then dragging and dropping them into a Folder together.

Save As

Some programs might require you to do a "Save As" procedure. When you have an image full screen on the monitor go to File and drop down the menu until you see the "Save As" command (PC users should right-click on the image to access this command). You can then name the file and place it into a Folder or Album. Choose the Album or Folder and follow the screen prompts. This method allows you to convert the file format from JPEG to TIFF or Raw to TIFF when you make the save. You can also do this with all the image files in the Folder using a Batch convert, if your software has that feature.

The reason to convert JPEGs to TIFFs is that when you open a JPEG and do any type of image manipulation—even, in some cases, rotating—you are going to lose some image information the next time you open the file if it is still in JPEG format. To repeat: Every time you open the file as a

One way to make format conversions is to do a "Save As" when you first open the file. The file conversion is available via a drop down menu accessed via the down arrow on the right of the Format box. Here, a JPEG image is being converted to a TIFF format. This ensures that no loss will occur when the file is opened and any editing is done.

JPEG and make any changes on it and save those changes the file loses some image information. TIFF files, when opened, do not. TIFF files take up more space on your drive, but the loss of space is preferable to the loss of image information and file degradation that JPEG compression causes.

Back Up

Once you have named, saved and perhaps converted the file the next step is to back up the file by burning a CD or DVD of those files. Making backup copies is the best way to archive your images, to free up space on your hard drive and to protect them as well. Many digital photographers keep images on their hard drive for a few months and then burn a CD and delete them from the drive. If you make backups right away you won't have to worry about losing them should your hard drive do what, unfortunately, hard drives sometimes do.

CD-ROMs can hold up to 700 MB of information, while DVDs can hold 4 GB or more. Burning software is easy to use. You open the program and drag and drop from your hard drive to the drive that holds the backup

media. You then label the medium and place it in your backup library on the shelf. If you want, you can keep all your images on the hard drive as well as the backup, but at some point you will find that the drive begins to fill up.

DELETING FOR GOOD

When you delete images from Folders in some browsers you do not delete them from your hard drive. Some browsers act as pointers to images rather than store the actual image file. If you delete from these browsers, you just eliminate the pointer—the thumbnail—and not the file itself from the hard drive. To delete for good you must go into the main picture storage area (for example, in iPhoto in the Mac, called the Photo Library) and delete from there.

Image Editing

With an image-editing program you can improve upon just about every picture you take. Some photos will require more work than others, but even quick enhancements of color, contrast and sharpness always provide a better image. Once you master these fixes you'll be ready to move on to more advanced enhancement and correction techniques.

Imaging Software

Any image-editing program can seem daunting at first, when you find yourself looking at a blank screen and ranks of buttons and icons that seem to make little sense. The best advice is to start with the basic fixes and then work your way into the more advanced techniques. Choose a few images and make them into projects. Use the tools and you'll soon become familiar with the way in which the software works and how to get from point A to point B. There's no such thing as a mistake—it's all about trying different routes and tools and having creative fun. The important thing is to learn just what might be necessary to improve an image (many software programs have very interactive Help menus and Wizards that will walk you through any process you try). Think about color, light and contrast and how each interplay with the other to create an attractive, cohesive image.

Loading the Software

Load the imaging software just as you do any other program. Wizards and Setup Screens will walk you through the process. Once you load the software, follow the instructions to register it and click "yes" when asked if you want to receive updates on your editing software. This way, you will be notified by e-mail (or regular mail, if you prefer) when the publisher issues updates or changes to the program. These can add considerably to the functionality of the program and also repair any bugs that might crop up.

File>Open

Once you have opened the program the first step is bringing the picture into the working environment. You do this by going to the File>Open menu. A "tree," or list of Folders and files, will appear. With most programs, all you need to do is double click on the Folder and then the individual image, and it will open in the software.

The ease with which you can find the file often depends on how you organized your images when you downloaded them. That's why naming your images, creating Albums and generally getting your house in order when you download makes this work so much easier (see pages 120–123). This also makes it easier to find images using your Browser.

CHOOSING YOUR SOFTWARE

Basic image-editing programs combine image adjustment with organizing functionality. Mid-level programs are for those who want to do more image manipulation but don't necessarily need professional-level tools, which are aimed squarely at professional photographers and priced to match. You can also use programs known as plug-ins in combination with image-manipulation programs or by themselves for such functions as colorization, sharpening or special effects. There are many special purpose programs for those who want to add pushbutton special effects, for e-mailing and sharing and for making simple web pages.

Before you go out and buy a particular program you may have a chance to work with it on a trial basis. Many manufacturers offer trial downloads on their web sites, which you can use for 30 days or more before you buy.

Each image-editing program has its own unique GUI, or graphic user interface, with some requiring a steeper learning curve than others. Most basic programs offer tutorials and lead you through every step of the way with Wizards or on-screen guides. The Microsoft Editor package provides simple word guides to various functions and features; this menu screen shows you how to change brightness and contrast, correct color bias (tint) and perform other basic imaging functions. The payoff for learning Adobe Photoshop (bottom), one of the most advanced and widely used programs for image editing and manipulation, is the ability to make virtually any change to an image.

Work on a Copy

When you open an image the original appears on the screen. Any work you do will change the image. Because your first (and subsequent) attempts should and will be experimental, protect the original image by making a copy and using the copy for your projects. You can save the copies in a Folder called Work Prints, or something to that effect.

To make a copy of the original on the monitor, save the image with the "Save As" command in the File menu. If the original file is named "apples," then name the copy as "applesedit" (the point is also to include the word edit so you don't confuse your working copy with the original). When the program asks where to save it, create a new Folder or Album and place the copy there. The image on the screen will now be "applesedit" and that's the one to work on. Also, if the original is a JPEG, save it as a TIFF to prevent image degradation the next time you open the copy (see pages 122–123).

Image-editing programs allow you to work on copies, so you can experiment without ruining or altering the original image. Some image- editing programs also have "undos," which allow you to try something out and backtrack to a previous step if your experimentation doesn't work out. The History palette in Photoshop can be used to make a Snapshot of each step of your editing process, such as these taken in the hand painting of the church photograph on page 130.

Basic Editing Options

Some of the basic image-editing procedures we'll cover here are rotation, cropping, color balance, brightness and contrast, sharpness, and red-eye elimination. You will make these edits differently depending on the image-editing program you use, but most programs are fairly easy to use and Wizards, Guides, and Help topics will guide you through the process. Use these aids when you start and you'll soon find yourself building a body of practical knowledge.

The Rotate command compensates for the fact that the orientation of the computer monitor is horizontal. Of course, you will probably shoot many pictures with a vertical orientation and when they open they may be "on their side." Some cameras might offer auto rotation, but many do not. To fix this use the Rotate tool and choose either a clockwise or counterclockwise rotation. In computer-speak a horizontal composition is often called "landscape" and a vertical is called "portrait."

The Cropping tool allows you to remove part of an image to improve composition or to eliminate an obstruction that you did not see when you snapped the shutter. Experienced photographers will tell you that many images improve through some judicious cropping, or reframing the subject. Keep in kind that when you crop you are tossing away some of the image information, so when you crop the file size will drop in proportion to how much you have taken away. Choose the crop tool and an icon will appear where you place the cursor. Drag the tool across the image to define the new frame then click the mouse or press the Enter key to affect the crop. If you make a mistake you can usually Undo it (which, in computer-speak means to cancel the action) with an option from the Edit menu.

Brightness controls allow you to lighten or darken an image and are usually distinct from contrast controls, although the two may appear in the same area. When you adjust brightness you are affecting the entire image unless you select part of the image to work on, a subject that will be covered in Chapter Nine. In some cases, an image that is too dark on the screen may have been underexposed slightly, a simple matter that you can correct with brightness adjustment. The same is true with images that appear too bright, although areas of gross overexposure (where the pixels get overwhelmed with light) will pose more of a problem.

Contrast adjustments provide you with one-touch control over a picture that it too harsh or too flat in appearance. If you have a dull-looking picture all you might need to do is "tweak" the contrast to make colors more vivid. Contrast

controls provide a simple way, for example, to add more dazzling colors to a fall foliage scene photographed under overcast sky. Contrast and Brightness controls provide an easy way to make a quick fix on many images.

Color Balance can be "objective" when you work with what are called "memory colors," such as skin tone, apples and other obvious color renditions. But color reproduction can also be "subjective," when true color is less important than the mood the color imparts. On the objective side, color balance might be off if the lighting conditions under which you photographed were not matched with the White Balance settings you chose. The subjective side of color balance comes into play when you want to add a color bias or wish to affect the mood of the scene. You can add a touch of blue to late-day snow scenes or a slight yellow cast to summer landscapes. This is where experimentation comes into play. If you like you can also remove color altogether to convert the image to black and white or, for an old-fashioned effect, turn it sepia. The Color controls might also allow you to change color saturation, or how vivid or pale the color you change will be. Color Balance controls usually work with sliders that allow you to alter color in any way you desire. You can add green or take away red or make an image with an overall blue tone. By combining the RGB controls you can attain just about any color in the spectrum.

Sharpness controls can be used to "punch up" a soft image or add kindly softness to a portrait. Be careful not to oversharpen, as this can add noise and excessive contrast. The sharpening control is sometimes called Unsharp Masking, a sort of backwards phrasing that means that you are eliminating some of the unsharpness.

Red-Eye Reduction addresses this bothersome effect that occurs when the flash and lighting conditions conspire.

The toolbar from Adobe Photoshop offers an incredible array of tools for image correction and enhancement. The Burn tool (highlighted) functions just like burning in the conventional darkroom to add "density" or exposure to a select part of the image. You can modify the tool to affect only highlights, midtones or shadows, and to apply a certain amount of "exposure" or degree of burn with each click.

Wizards and help boxes make it easy to became familiar with tools, workflow and best applications for your editing and manipulation tasks. This help box in Photoshop Elements shows you how to enhance color in the photo.

REV UP THE RAM

One thing you can do to enhance your image manipulation work is to add as much RAM as possible to your computer system. RAM is where the work of digital imaging gets done and more and more programs have become RAM hungry. You can add RAM yourself or have a computer store or service company install it for you. Most programs require at least 256 MB of RAM, although some photographers suggest 1 GB of RAM for real imaging power.

The easiest form of red eye control is the tool of the same name. This turns the cursor into a circle that you place over the offending pupil. One click will fix the problem. It's important to use the right size circle as using too large a diameter will give an equally weird effect to the subject.

Zoom Controls

There are times when you need to have a closer look at the details while editing images. Use the zoom control to magnify the image by placing the tool cursor over the area you want enlarged and clicking. If you want to back off from the magnification simply click on the "zoom out" tool and do the same. Like many tools, the zoom control has a keyboard shortcut, which on Macs is usually Command + (hit simultaneously) and on the PC is Alt +. You can also use the zoom tool to see critical areas of sharpness, or just to have fun and zoom in until the image breaks down into pixels.

Painting Your Picture

Most image-editing programs allow you to change select colors or to add color to whatever part of the picture you desire. Most programs offer tools that work like pencils, paintbrushes and even airbrushes. You select the color from a color picker or palette and load the brush or tool with color. You can then change the size of the brush or tool and even how opaque that paint will be. You can use a low opacity to add just a touch of color to parts of the scene or paint completely over parts of the image. You can even use an Eyedropper Tool to pick up specific colors from your picture and load that color onto your brush.

If you don't have a tool specifically for red eye, you can use the paint tools to remedy the situation. Simply size a brush to fit right over the pupil and load the brush with black. You can then paint right over the red area with one click of the mouse.

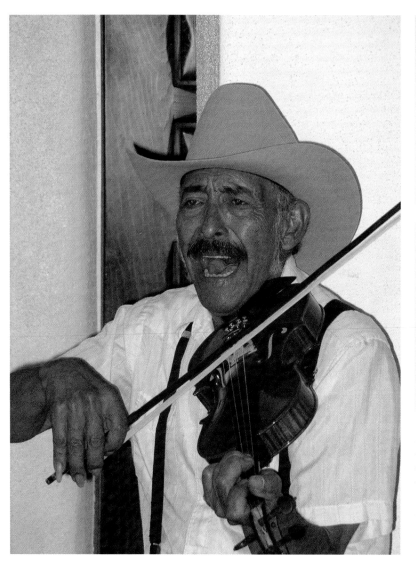

Upon first inspection, no red-eye effect seems evident in this image of a musician photographed from across a room using a direct flash and telephoto setting on the zoom lens. But the Zoom tool reveals its telltale presence, and the Red-eye brush tool in Photoshop Elements makes quick work of the bothersome effect.

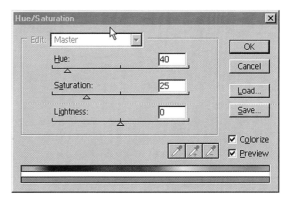

With the Hue/Saturation tool in Photoshop and similar tools in other programs, in just seconds you can change all the colors at once (as shown) or select distinct colors to change.

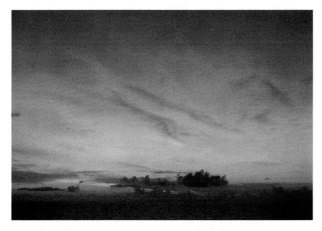

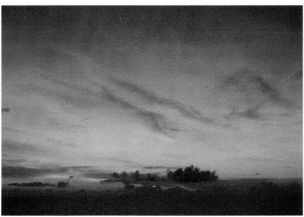

YOU'RE ALLOWED TO CHANGE YOUR MIND

There are times when you are working on an image and you make a false step or an experimental path leads nowhere. You can back off a single step with a simple Undo command, usually found under the Edit menu. If you then want to see that step again, go back to the Edit menu and click on Redo.

If the tool you are using has a dialog box (a set of options or commands that come up when you select the tool) you usually will get a Preview screen to help you see what will happen if you click OK. If you are working with a program that has a History palette (a list of the actions you have taken) you can also open that palette and delete some steps or even a set of steps easily. The History palette is also a great learning tool, as you can click on each step and see what sort of creative path you have followed. Each time you click on a step, or what some programs call an image "state," the image on the screen will revert to that state. By contemplating the series of steps you can learn what you did right, and what you might have done wrong.

Auto Correction Controls

Just as your digital camera has Autoexposure and Autofocus modes, image-editing software often offers a wealth of Auto quick fixes. These might include Auto Contrast, Auto Levels, Auto Color Balance and so forth and are generalized solutions to typical image problems that may or may not work for you. They are quite amazing in how they work, as each control evaluates an image and makes a correction in very rapid order. Try them out and see how they work for you; they will at the least give you a glimpse into the possibilities. Some programs have tools such as Fill Flash (which brightens the image) and Shadow/Highlight control, which allows you to balance the brightness values in the image. Again, experiment with all these tools to see if they do the job for you.

Variations

Some programs will show you possible variations on an image in terms of color, contrast and brightness. In Adobe Photoshop this tool is called, aptly, Variations. When you have an image open on the screen find the Variations option (under the Image>Adjust menu in Photoshop) and click on it. A grid of possible changes to your image appears, with color as well as light and dark and contrast variations. All you need to do is click on the variation you like and the program makes the changes on the image for you. You can make any number of changes in all the variables. A valuable part of this tool is that it always shows you the original and the changed image side by side on the screen.

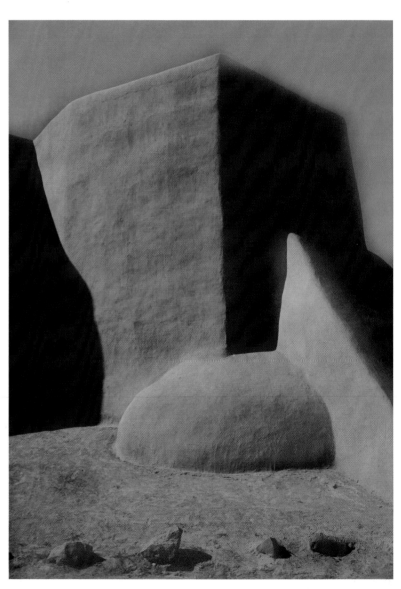

This photograph started out as a black-and-white negative and was scanned. Colors are loaded to a paintbrush using a color picker—the one shown is from Adobe Photoshop. The finished piece is composed of three colors applied with various "opacities" and color saturation options.

Upon opening, this photograph was too dark. Autoexposure corrects the exposure problem and a Burn tool set at Highlights, 20 percent, burns in the background so no harsh areas distract the eye from the subject.

Getting the Most Out of Your Images

Printers

Paper Surfaces
and Inks

Internet
and E-mail

WHILE DROPPING A DIGITAL MEMORY CARD OFF AT A LAB and having someone else make the prints is convenient, only you can give an image the fine-tuning that will express your creative vision. Besides, making prints of the images you take with your digital camera is lots of fun; affordable photo-quality digital printers allow you to make great prints economically; and the latest inks and papers provide an impressive variety of creative options.

Computerless printing: I printed this image by inserting the memory card right into the printer, then enhanced the color saturation, using printer controls and made an 8 x 10 print, without ever using the computer.

Printers

Inkjet and dye-sublimation printers both deliver prints of excellent quality. Dye-sublimation printers are easier to use and more portable than inkjet models are (some are small enough to fit into a briefcase), while inkjet printers can accommodate a very wide range of paper types and have a larger print-size capability. Compare the differences:

Dye-sublimation printers

- Work with a ribbon coated with colors and paper specific to the printer. The color is diffused onto the print by heating heads within the printer.

- Generally pass the paper through the printer three or four times—three for the application of color and the fourth for coating the print surface with a protective UV (ultraviolet) shield.

- Might limit your print size to 4 x 6 inches, although you can get models that print up to 8 x 10 inches as well.

Inkjet printers

- Work with inks that are sprayed by ultrafine nozzles onto the paper.

- Pass the paper once, during which time the ink is laid down line by line.

- Use a wide range of papers available in a number of different surfaces, from glossy stock that resembles a traditional photo print to canvas, silk and fine art acid-free papers.

- Can print onto sheets as large as 13 x 19 inches. If you want larger prints you may have to go way up in price or work with a commercial lab that can maximize your digital image files.

Printing from Your Image Editing Software

While it's possible to make prints without using your computer, you'll probably find it far more satisfying to work with your image-editing program and desktop printer.

The first step, of course, is to install the printer software, which creates a handshake between the printer and the computer and provides the basic foundation for what's known as color management, the way the image color is read and translated by the printer.

After editing and manipulating the image, you must go through a few steps to prepare it for printing.

Make sure the image will print out at the size you want and at a resolution level that will yield a quality print. Do this by using the Image Size (or Resize) dialog box. Open Image>Size (or Resize). A box will appear that has a number of components. Look at the resolution first. This might read 72 dpi. This is the screen (monitor) resolution. You will want to change this, because if you print at this resolution you will have a very poor result. For most inkjet printers you should set this number at between 240 and 300 dpi. Some printers may deliver good results at resolutions below 240 dpi; you will have to experiment to see how low resolution can be to yield the best results.

Look at the image size. This tells you how big the print will be at that resolution. If the size is smaller than you'd like, change the resolution, but again you must test to see how low you can set this figure.

If this still doesn't bring it up to the size you desire, check the Resample box and add some more size and maintain the resolution. Resampling adds image information by sampling pixels and building in more. This can be helpful but it does have its limits—you can usually go about 20 percent above the original file size and still get a clear print. If you think you need to go bigger, resample again (at no more than 10 percent per step) and watch the results carefully. Resampling too much will begin to deteriorate the image.

As you work with this dialog box you'll see how all these numbers work together. When you change the resolution you will see how the image size changes. If you change the image size then your resolution will change. The file size (the pixel dimensions at which you first photographed the image) remains constant unless you resample. If you resample up then the file size increases.

You can buy software solutions that will help you get the biggest size from each image. Keep in mind, however, that they all work on the principle of constructing more pixels and cannot add "real," or recorded image information—that comes only from your record when you make the image, so it's important to photograph using a resolution that matches the desired end use of the image. If you want to make large prints, you should use the largest pixel resolution your camera affords; you can shoot in any image mode—TIFF, JPEG or Raw—as long as you do so at the highest resolution. If you want to make small prints, shoot at a medium pixel resolution. If you want to

use the images on the Internet, as part of a web page or as an e-mail attachment, you can use even smaller resolution sizes (see page 42).

Even with the best resampling methods and software, if you recorded at too small a resolution you'll be limited to small prints. On the other hand, you'll have no problem making a small print from a large file size.

Printer Properties

Once you have entered the size and resolution, the next step is to open the Print dialog box. This will show the name of the printer and a box named Properties. Click on this box. In the Properties box you'll see a number of tabs and pull down menus. Each printer may have a different box, but in any case you should choose the Advanced or Custom tab. This is where you choose the type of paper you have in the printer—an essential piece of information.

Each paper surface and type will handle ink in a different way. If you notice that your prints are marred by banding (lines running through the print) or pooling (where ink seems to smear or sit on the surface improperly) or that the colors are way off, making the right paper surface choice might be the cure. If the paper you are using (which includes brand) does not appear in the options then you will have to test. Some paper companies publish what are called Profiles on their web sites. Go to a site and download the profile, then load it into your printer options. Be sure to do this if you use papers other than those in your Profiles or if the testing you do does not yield satisfactory results.

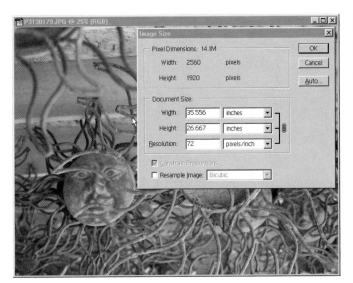
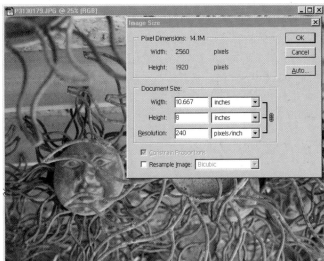
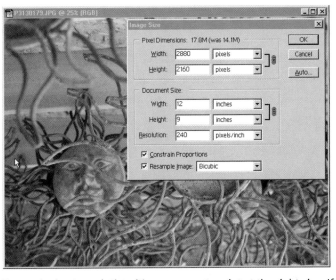
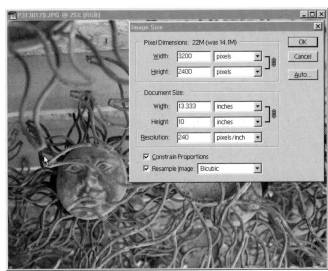

To get the best resolution, it's necessary to print at the right size. If you want to print at a larger size, you can construct additional pixels by checking the Resample box in the Image Size dialog box. This series shows the steps required to go from an 8 x 10 print to an 11 x 14.

Next, click on the Paper Size options and choose the paper size you have fed into the printer, whether you want the image to be centered, full bleed (printing edge to edge with no borders) and any other instructions you might want to give the printer. Check Color for the ink and Automatic for the mode. If you want to add more color richness you can check off PhotoEnhance, if available. You then select Quality or Speed. Always use Quality for the best results by sliding the bar to the Quality setting.

It's important that you test all the possible color enhancements and options the Print dialog box offers. Each photographer has a different interpretation of how a print should look and these Custom options allow you to

play. Make test prints of various subjects with each option and judge for yourself; consider keeping a scrapbook with the different options so you can use them to get just the right look for every subject and scene.

As mentioned, each printer may offer different settings and properties, or a different way to make settings. But with each printer you should be aware of how to make the choices outlined above. When it comes to print quality, making the right settings in the Print Options dialog box is almost as important as making the right choices when you do your image manipulations. Take the time to test and experiment when you get the printer and you'll be rewarded with better prints in the future.

Follow the steps listed in the Print Options box under File menu to ensure that you get the correct ink spread and other elements of optimum color print quality.

DPOF: COMPUTERLESS PRINTING

DPOF stands for Digital Print Order Format and allows you to print directly from the memory card with a memory card capable printer. When you review your images in your camera you can set a print order to be attached to the file. This order can vary according to the camera; some allow you to order a certain number of prints, their size and even if you want them made with or without a border. You can select all the pictures, choose only certain ones to print, and even create an Index print with thumbnail size images of all the images on the card.

DPOF setup is slightly different on each camera, so check your instruction book on how to access this feature from the menu. In general, you select DPOF mode (sometimes called Print Order or Print Reserve) and then select or highlight the images you want to be placed on the order. Once you have made your print order on the card, you insert the card directly into a DPOF compatible printer or, with some cameras, patch the camera right to the printer and make prints from the card that way. Check your printer instruction book. Some will only work from JPEG files, may have a limitation on pixel size (for example, 640 x 480) and may only be able to handle a set number of images from a card.

Most printers are set up to receive standard cards, but some may require you to use an adapter into which you slot the card before sliding the adapter into the printer. Some printers even have monitors on which you can preview each image again before you make a print, and most have a control panel that allows you to select paper size and paper. After you have inserted the card, the printer software will walk you through the steps. In general, for DPOF-formatted cards, the printer will recognize the print order and all you have to do is press the Print button. If you want to override the DPOF settings you can do so as well.

Some direct-from-card or direct-from-camera printers might also offer enhancement settings that might include the ability to make a print lighter or darker, to soften the image, to increase color saturation or contrast, or to adjust any combination of these elements. When you first use the printer, experiment with these enhancements to see how they affect different subjects and scenes. These enhancements do not change the original image file; the printer software adds the enhancement when it processes the image for printing.

You can patch from many cameras directly to a printer, using the camera's DPOF (digital print order format) setup.

The Properties box allows you to choose paper size, to resize images and in other ways ensure you get a high-quality print. Choosing the type of paper you are printing on can have as much of an effect on print quality as any manipulation you do in camera or in your image-processing software.

Paper Surfaces and Inks

With dye-sublimation printers, it's necessary to use the manufacturer's color ribbons and paper. Some, though, can handle more than one paper surface, but the choices are usually limited to glossy (shiny) or matte (flat) paper types.

Inkjet printers offer a much wider choice of papers and inks. Papers are available in a wide variety of surfaces, including glossy and matte finishes that look very much like the finishes of standard photo papers, as well as more exotic choices, such as silk fabric and those that look and feel like paper used by watercolor and oil painters. In fact, these choices allow you to print on just about any surface available to artists and printmakers in all the graphic arts.

The table at the bottom of this page shows some generic guidelines for selecting the most appropriate paper for your work.

The thickness of the paper and the way it receives ink will have a lot to do with the resulting image quality. If you're not sure which paper to use, see if the manufacturer offers a sampler pack that will allow you to test different types of papers with various subjects and scenes.

Ink Choices

When it comes to choosing ink for an inkjet printer it is usually best to stick with the ink made specifically for the printer by the printer manufacturer. Various third-party ink makers also offer inks for the printers, but be cautious when using these. The ink cartridge you use must fit in the specific printer, and since inks are made with a certain viscosity, using the wrong or poor quality ink may clog the inkjet nozzles and lead to costly repairs or necessitate a cleaning that you probably want to avoid.

Some ink and paper combinations work better than others, but you can only judge this by testing one against the other. The differences can be profound, so don't be discouraged if your prints don't come out the way you expect. It might simply be a matter of changing the paper you use. This is especially true of the difference between photo paper and premium photo paper. Not surprisingly, the more costly paper usually yields better results.

Matching Paper and Ink

Perhaps the most important step in getting quality prints is matching the paper with the correct media type in the printer software dialog box. This match is sometimes called a Profile, which provides a way of creating a handshake between the paper, the ink and the computer. If you use a paper branded by the printer manufacturer, the Profile will usually be available in the printer setup box, placed there when you load the printer driver. If not, you can often obtain the Profile from the paper manufacturer's web site or on instructions in the paper packaging.

Make sure this Profile is set when you are ready to print. The Print dialog box will display a box called Properties. Click on it and it will display a menu called Media Type. Click and scroll on this box and select the paper Profile you are using by matching the type of paper with the displayed list. You may see Plain Paper (for documents), Photo Quality, Premium Glossy, Photo Paper, etc. If you have loaded a Profile you will see it there as well. Matching the paper means that the ink will be distributed accordingly. If you get poor results, check that the paper type has been matched, as this is usually the chief cause of problems.

WHAT PAPER TO USE

Type of Paper	End Use
Photo Paper	Snapshot prints, medium quality enlargements
Premium Gloss	Enlargements, best sharpness, best quality, shiny surface
Heavyweight Matte	Fine art enlargements, nature scenes, flat surface
Premium Semigloss	Portraits, enlargements, scenics, best quality
Photo Quality	Medium quality enlargements, glossy surface
Sticker Paper	Creating photo stickers
Acid-Free Rag	Fine art, color and black and white
Transparent Film	Overhead transparencies for presentations
Fabric, Canvas	Special projects

Internet and E-mail

The chief differences between making prints and creating images for e-mail and web pages are the image sizes and resolutions you choose. When you make an 8 x 10 inch print you might be working with an 18 MB file. This is much too large to send in an e-mail or to include on a web page.

In our discussion of pixel dimensions and format choices we emphasized that the smaller resolution mode choices on your digital camera are best for Internet and e-mail pictures. If you are working strictly for electronic images (no prints) then simply choose the smallest resolution your camera allows, keeping the compression at a low level, such as 1:4 or 1:8. This might be shown as 640 x 480 or 1280 x 960. Ideally, the final file size for e-mailing and web pages should be under 500 K. This might change as broadband sending gets better, but for now and in the near future that's as big as they should be. Indeed, some web and e-mail images should be under 100 K.

In addition, most e-mail and Internet photo images use JPEG file format as the standard—indeed, most cameras and software programs will only allow compression in JPEG mode. If you originally recorded the image in TIFF or Raw format you can make the conversion using the Save As command. When you do so you might be asked by your software program to indicate a Quality setting. Place the setting in a range that encompasses 5 to 7 and follow the instructions for best performance. If you are going right from your digital camera's JPEG file there's no need to make the conversion.

If you originally recorded with a larger file size than you need for the web or e-mail, you can open the image, duplicate it and resize it. Do this with the Save As or Save

a Copy function. When you get the copy open resample it down to the size you need. Resolution should be set at between 72 and 100 dpi.

Special E-mail and Web Functions
Check your camera instruction book to see if your camera has an e-mail function. This might work in two ways. One approach allows you to take a picture at the normal resolution you have chosen and at the same time makes a smaller file size copy, giving you two images with one push of the shutter release button—one "normal" and one especially for e-mailing. Another is an after-exposure function that does similar work by making a smaller file size copy for you after exposure

Some e-mail and image-editing programs have a Save for Web function, which makes your job easy. When you open Save for Web (or similar title) the program shows you two views—the original file and the "shrunk" file. There might be a number of options available, such as color gamut, etc. As you make your selections you get a preview of what the transmitted image will look like on the screen and how long it might take to transmit and be received with different speed modems and connections. This is the simplest way to go as it eliminates the need for you to make any complex calculations.

Placing Images in E-mails and on the Web
If you want to e-mail an image, all you need to do is attach it to your document as you would any document. Each type of e-mail program will have a different way to do this, but they all boil down to choosing an attachment. In addition, some image-editing programs, especially those geared toward amateurs, will have an "e-mail this image" icon that may actually do all the resizing and attaching for you.

The same type of procedure is followed when you make images for your web page or a web-sharing service. If you are placing images on a web site, such as an auction service, you need to take the time to resize them and make sure that they will not take a long time to download.

The only time you might have to upload larger image files is when you are using a web site to get prints or gifs from your images. If you send the low-resolution images you will not be able to get good larger prints or decent images on gifts such as tee-shirts, mugs, puzzles etc. In this case you still need to convert to JPEG (usually), but you will need to provide as large a file as you can. You can compress the file if necessary but be sure to keep the resolution setting as high as you can.

The simplest way to create an image for the web or for e-mailing is to use the "make ready for web" functionality in your image-editing software, where dialogue boxes enable you to choose dimensions, quality level and format.

Image-editing programs make it easy to construct web pages and albums you can share. The first step (top left) is choosing a folder from which you will be retrieving images, then inputting the desired size. The program finds the images and shows you a preview (top right); you can click on an image to make it full screen (center left). Programs help you construct a web page quite easily; here are my home page and one of my gallery pages.

Advanced Image Editing Tools

Layers and Modes

Selection Tools

Image Control Techniques

Monochrome Controls

Sharpness (Unsharp Masking)

Special Effects Filters

Plug-ins

IF YOU PUT TEN PHOTOGRAPHERS IN ONE PLACE AND ask them to make a picture you'll probably get ten different pictures. You'll find the same thing occurs if you put ten different people in front of an image-editing program with the same picture on the screen . . . each person will find a different way to accomplish similar tasks. The process becomes even more complex and variable when you add the many advanced image-editing tools and applications that are available. Here we'll take a look at those I have found to be the most applicable to correcting and refining digital images. My advice is to use any program until you are comfortable with it and learn what it can do for an image, and to upgrade or change only when you feel you have been stopped somehow in your capabilities or you find a new program that takes you further in your work.

You might be tempted to toss this overexposed photograph but a Levels Adjustment Layer with a Multiple Blending Mode corrects the exposure. The Solarize option from the Filter menu darkens the image but reverses tones and makes colors run wild, while Hue/Saturation controls change the color play.

Layers and Modes

One of the most effective tools we have at our disposal is something called—in Adobe Photoshop and Photoshop Elements—an Adjustment Layer. You can use one or many Layers to work on your image, with each one addressing one aspect of the task at hand. (Other programs may work with Layers as well, but they may be labeled differently.) Adjustment Layers can be used to alter contrast, correct for color imbalance, change exposure, convert color to black and white (globally or selectively in the image) and more.

Think of a Layer as a filter through which you view the image. Imagine that you have placed the image at the base of a box that is illuminated from beneath. That box has a series of slots into which you can slide filters, or image effects, in and out. Those filters do not affect the image information itself, but are mathematical computations that propose an image change. When you use a Layer you are sliding in a proposition, such as a change in contrast. You can slide it in and if it works, fine; if not, then you can slide it out.

You can modify each change as much as you like and, for example, make a large or small change in contrast. You can even modify the filter so that the contrast change only affects a certain part of the picture. When you have arrived at a solution you can keep the filter in place. Having the power to slide the filters in and out, and to modify them very finely, allows you to try many different methods and approaches to getting the best you can out of the image.

Blending Modes

Modes, or Blending Modes as they are called in Photoshop, provide a way to add a certain mood or feeling to Layers. There are more than a dozen Blending Modes, but the ones that are most useful in your work are Multiply, Screen and Overlay. You apply a Mode to an Adjustment Layer to flavor it, if you will.

Multiply adds density (in a sense, exposure) without changing contrast. It's hard to quantify it, but if you have worked in a wet darkroom think of it as adding a stop of exposure to a print under the enlarger. Screen lightens the exposure about a stop without changing contrast. It is often used to add what's known as a "high key" effect to an image. Overlay adds about a grade of contrast to an image without changing exposure.

Modes are really shortcuts to what you might do to the image later with more complicated procedures. Often, you can edit an image to your satisfaction just by applying these changes with an Adjustment Layer. You can modify Modes and Layer effects easily with something called an Opacity control, a slider in the Layer palette that allows you to dial back the effect from full (100 percent) to near 0 percent (removal of the effect entirely.)

THE IMAGE LOOKS BACK AT YOU

Once you have opened an image in your software you should take a moment to contemplate what can be done to refine and enhance it. You may have a number of goals in mind, but you might find that once you get a handle on what you can do you may end up at an entirely different place. That's the magic, and sometimes the frustration, of this process. The magic comes from the ease with which you can experiment; the frustration can come from having too many options and not knowing which way to go.

There are two approaches you can take—making the best "straight" photographic image from the original or going what I call "graphic" and letting your imagination run a bit wild. My advice is to first master the "straight" approach—to get the best color, tonality and contrast you can—and then, if you desire, have at it with a more special effects approach. In any case, to create an image you should first consider its components and deal with each one as a foundation for later work. The end result of your work should be to maximize each component in a way that serves the visual communication of the picture, whatever the subject or the scene.

Sometimes the only image-adjustment tools you might need to use are Adjustment Layers with Blending Modes. Clockwise from top left: This photo of backlit leaves is well exposed, but we'll apply some Blending Modes to see the effects. Multiply Blending Mode creates an effect similar to taking away a stop of exposure from the scene; it darkens the photo without changing contrast. Screen Blending Mode creates an effect similar to adding a stop of exposure; it too does not change contrast. Overlay Blending Mode adds a step of contrast to the scene, and is an excellent tool to use when scanning old, faded black-and-white photos from the family album.

Layer Masks

A Layer Mask provides another way to modify a Layer, by allowing you to add or subtract from the effect using Painting tools. Using a Layer Mask is like using dodging and burning in the darkroom and is one of the best shortcuts to complete image control.

For example, say you have opened an image and it is too light in some areas. You first apply an Adjustment Layer (say in Levels) with a Multiply Blending Mode. This darkens the image. You then use a painting tool to paint back (or remove) those areas that were originally well exposed and leave the darker areas brought in by the Blending Mode. If you overdo it you can "reverse" the tool to paint back the areas you have removed. You can also modify the application of the tool with Opacity sliders in the Layers palette.

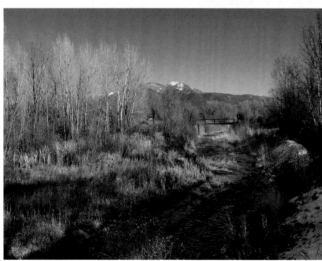
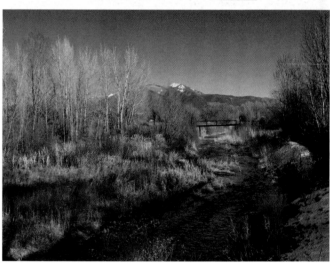

Layer Masks allow you to work some real image magic. Clockwise, from top left: This exposure, while lacking richness and full tonal play, delivers as much of the values as possible. The task is to bring color richness to the scene without sacrificing shadow detail. In Photoshop, you can create a Layer then remove part of the Layer using a Layer Mask technique. The fist step is to make an Adjustment Layer with a Multiply Blending Mode. This darkens the entire image, but you can use a Paintbrush or other painting tool to open up the shadows. Finally, you can use the Hue/Saturation tool to add saturation to all the colors.

Selection Tools

Making a selection means that you can work on part of an image without affecting the rest of it. For example, say you want to add density to the sky but keep the ground at the same exposure and/or contrast. You select the sky and the ground is then protected from any changes. You could then invert the selection to work on the ground area, to the exclusion of the sky.

You can also select, with some programs, pixel values or groups of pixel values for change. You first identify the tone or tonal range and then click to select all similar

The easiest way to adjust color and color saturation is to use the Magic Wand tool and Replace Color options to make your changes. Clockwise from top left: In an image of a colorful wall, you can select the blue triangles and change them with Replace Color or the Hue/Saturation Adjustment Layer. The light green seems to clash, so to bring colors into harmony you can change them to orange. The next step is to try out a saturation change and to lower color vividness throughout the picture with the Hue/Saturation control.

values. You then reassign values to those pixels. You can make Selections by using oval and rectangular shapes or you can draw them freehand.

Burning, Dodging and Other "Mechanical" Tools

Some tools are "mechanical," in that you apply them with some wrist motion using a stylus or a mouse. These tools allow you to:

- Add or subtract density to certain areas using burn and dodge tools, and if you wish, to work only on certain tonal values, such as highlights, midtones and shadows.

- Paint with any color or tonal value you desire, in varying degrees of opacity, using tools that work like a paintbrush,

pencil or airbrush. You can pick up colors right from the image using an Eyedropper tool. And you can pick up select portions of the image and copy them elsewhere in the image with a cut and paste tool known commonly as the "Rubber Stamp," or "Clone tool." This is the main tool you'll work with when retouching an image.

In some images you might use some or all of these tools. For example, in one image you might use the Burn tool to tone down a highlight or even darken an already deep shadow. Then you might choose the Dodge tool to lighten eyes or reveal a face partially hidden in the shadow of a hat, then the paint tools to add color to a blank area or enrich the lips of a portrait subject. The Rubber Stamp tool might come in handy for removing dust from a scanned picture.

This photograph of a jar against a painted wall is a prime candidate for some image manipulation fun. Quick Mask mode places a red mask around the area to be refined with a paintbrush, zooming in close to the edges. A Solarize Filter reverses some tones and results in vivid colors, and the Hue/Saturation Adjustment Layer changes the colors of the fence. All these changes are made possible by the ability to automatically select, then change, pixels with unique or similar addresses.

Although the overall exposure is fine, the goal here is to make the subject more pronounced and to add a dimensional feel by making him lighter. After using a rectangular Selection tool to identify the area in the image you want to change, lighten the area using a Levels Adjustment Layer on Screen Blending Mode. Then, burn in the ground to make it blend more with the scene.

Image Control Techniques

A few common applications are essential to working on any image. They include contrast, brightness and color control. We can use each individually and in combination to get the most out of each picture.

Contrast Control with Levels and Curves

Contrast is an interpretive matter that will be determined by each picture, but the best course is to try to get the most values out of the image. Your main tools for contrast control are the Levels and Curves tools. Let's look at Levels first.

When you make an Adjustment Layer, select Levels and a dialog box will appear. The Histogram shows the spread of values in the image going from shadow to highlight, left to right. If the values do not stretch across the entire box you can move in the sliders to touch the edge of the graph. This spreads the values out and the contrast will change. Play with the sliders and you'll get a very good sense of just how much control you have over image contrast. You can also move the middle slider (the so called Neutral Gray) to change the contrast.

After you have made the change click "OK" and the contrast adjustment will appear as a Layer in the Layer palette. Click the eyeball next to the Layer and you will see the difference. If you open up the Levels box again or just show a Histogram of the image, you'll see that the values have now been spread throughout the image.

This may or may not be your final approach to the image, but this is the way to open values and might be all you need do to correct the image. In addition, you can modify the change as you wish by using the Opacity slider in the Layers palette dialog box from full to partial effect by moving the slider to the left.

Another powerful tool is Curves. (Note that some image programs do not have a Curves control.) Curves provide a classic way to read the various tonal values in an image, but here the Curves control allows us to modify and enhance the tones further. Using your cursor, click on a value within the image while holding down the Shift key. That value will then be identified as a point on the line within the Curves dialog box. You can then "grab" that point with your mouse or stylus and move it around as you desire and watch the results. This can be used to tame highlights, open up shadows and modify particular tonal and color values to a very fine degree.

Using Levels and Curves you have complete control over the contrast and tonal values of an image. You can also select certain portions of the image and apply the effects only in those areas. There are other ways to affect contrast, but these tools are the most effective and powerful you can use. Once you get a handle on these two you will go a long way toward having complete contrast control over your images.

Exposure Controls

Exposure can be thought of as the overall brightness of the image. There are two approaches to exposure—corrective and interpretive. Corrective Exposure controls are those that change the image on screen to match the brightness levels of the original scene; interpretive controls allow you to alter the overall brightness as you wish.

If you have overexposed or underexposed the picture, it is quite easy to make the appropriate adjustments using the Brightness controls. You can also select portions of the image and add or subtract brightness from them. In some programs you might have shadow and highlight controls such as Backlighting and Fill Flash, which allow you to choose (with sliders) nuances of those values.

One of the best Exposure controls can be found in the Blending Modes, accessible when using an Adjustment Layer. Use Multiply to add density and Screen to reduce density. Once you have applied the Blending Mode you can then nuance it by using the Opacity slider in the Layers palette. You can keep it as is at 100 percent or halve or quarter it (or make any adjustment you like) with the slider control. You can use multiple Layers to keep adding or subtracting exposure to select portions of the image with these modes. For even more control, use these tools on a Duplicate Layer.

You can also add or subtract exposure from selective areas by using the Burn and Dodge controls. When you use these controls you can pick the brightness values you want to adjust by selecting Highlights, Midtones or Shadows. When working with Burn and Dodge tools it's a good idea to set the exposure low—around 18 percent—and to make your changes in steps rather than making them all at once by using a higher exposure, such as 50 percent. This method allows you to have much more control over the change and to watch it build as you go.

A quick fix for exposure is to use Variations or a similar option filled editing step. This gives you one-click control over making an image lighter or darker. It also keeps the original on the screen as you work so you can always compare the new image to the original picture.

Color Controls

There are so many ways to control color that it's best to choose one or two to start and then to explore the other options as you gain experience. One of the main controls is Hue/Saturation, which you can use through an Adjustment Layer or through Image>Adjustments in Photoshop. When you open the Hue/Saturation dialog box you are given three options—Hue, Saturation and Lightness. Hue describes the actual color, such as red, green, blue, orange etc. Saturation is the character of that color, which can be vivid, muted, neutral, etc. Lightness is the brightness of the color. As you move each slider you can watch the changes as you go. You'll also see a "Colorize" option, which we'll cover in the Monochrome controls later in this chapter.

You can apply the color changes over the entire picture or selectively, by making selections and then adjusting color in just that area. For example, you can select blue and make your blue sky more vivid without changing the other colors.

You can change the color cast of an image with ease. The simplest way is to open the Curves dialog box and select one of the Color Channels. Say an image has an overall blue color cast, because you did not select the

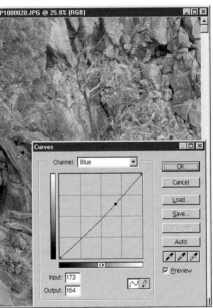

A color cast can result from photographing with the wrong White Balance setting or the camera's inability to make the adjustment in Auto White Balance. I photographed this tree in the shade of a cliff and the resultant image has a strong blue bias. I used the Curves control and set the channel on Blue. Once the Curve dialog box opened I suppressed the blue simply by sliding the curve downward to bring truer color back into the scene.

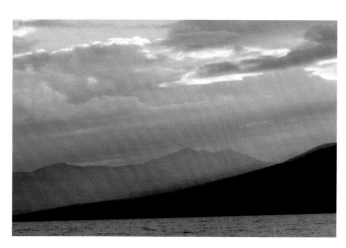

Color Variations
Before After
Tip
...le tones, dark areas, or light areas). Drag the
... a thumbnail preview to make your image
...ttons below to adjust your image.
e Green Increase Blue Lighten
e Green Decrease Blue Darken
OK
Cancel
Help
Undo
Redo
Reset Image

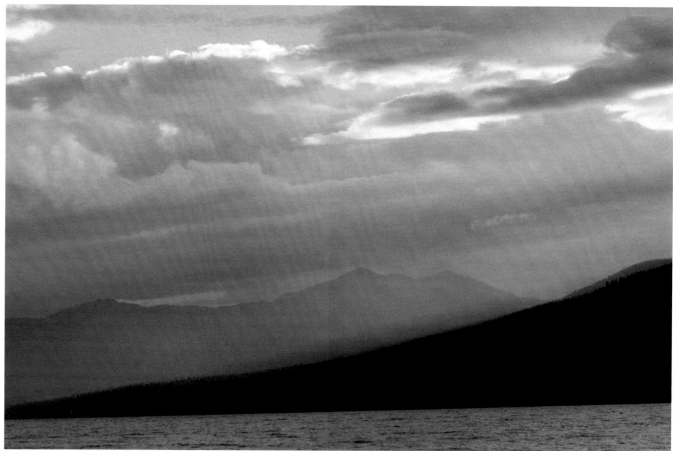

One of the simplest ways to try out different image effects is with a function widely available in image-editing programs and known in Photoshop as Variations. Here, Color Variations pose different moods for an image of a Montana sunset. All you need to do is click on different variations to get very different visual feels.

correct White Balance in the camera when the exposure was made or because you shot in the shade. All you need do is select the blue channel in Curves and change the shape of the curve to "suppress" the blue.

You can also swap colors with ease. Use the Eyedropper tool to "pick" a color from the scene and then use the Replace Color dialog box. The color you pick can then be swapped with any color via a dialog box that is, in essence, the Hue/Saturation controls box.

Coordinated Controls

Color, contrast and exposure all work in tandem. Changing contrast or brightness affects color; changing color can affect contrast. The final picture you get, and the way you got there, should work together to give the image a cohesive look. Tones should blend, colors should work together and brightness values should all come together to give you a feeling of continuous tone and rhythm throughout the picture. If one area seems too harsh or bright in relationship to the others it will take away from that cohesive feel. Of course, you are free to break the rules and try different effects and combinations. But when you begin, try to get as good a "straight" rendition as possible, then head off wherever your creative instincts lead you.

I scanned this black-and-white negative in RGB Mode and brought it into the digital darkroom. There, I added some warmth using Hue/Saturation and checking the Colorize option. Then I added just two colors, green and brown, using the Paintbrush tool set at low opacity so only a slight tint of color was added with each stroke. To finish off the image with the desired mood, I applied an Adjustment Layer with Multiply Blending Mode.

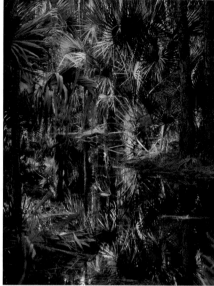
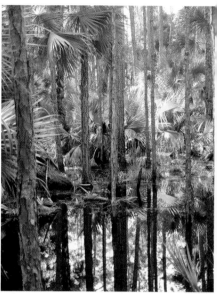
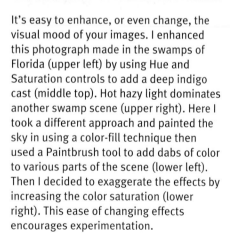
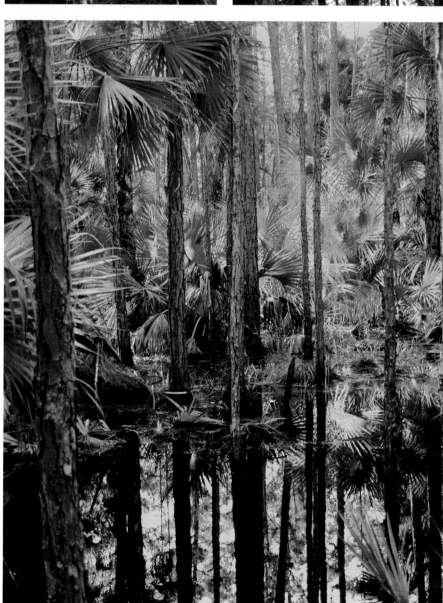

It's easy to enhance, or even change, the visual mood of your images. I enhanced this photograph made in the swamps of Florida (upper left) by using Hue and Saturation controls to add a deep indigo cast (middle top). Hot hazy light dominates another swamp scene (upper right). Here I took a different approach and painted the sky in using a color-fill technique then used a Paintbrush tool to add dabs of color to various parts of the scene (lower left). Then I decided to exaggerate the effects by increasing the color saturation (lower right). This ease of changing effects encourages experimentation.

Monochrome Controls

Black-and-white pictures can be highly expressive. They remove what some call the "distraction" of color to reveal the pattern, texture and tones of a subject or scene. They also appeal to the eye in the way the tonal values relate to one another. Your digital camera records in color; in most cameras, even the Black-and-White, or Grayscale, Mode is actually a color image file with the color "desaturated" or removed.

You can convert a color image to black and white in any number of ways. In Photoshop you can simply convert from color to black and white by using Image>Mode and selecting Grayscale. This removes the color from the image and cuts it down from a 24-bit to an 8-bit image. You do not lose resolution when you do so as you are "reading" the luminance channel and using that as the basis for creating a feeling of continuous tone. You can then go about changing the contrast and brightness as you see fit.

Another path is to choose Image>Desaturate, which removes the appearance of color but keeps the file as an RGB (color file). This is a good way to do it if you want to "tone" or colorize an image, such as giving old photos that you've copied a "sepia" or old-fashioned look. To create the color tone all you need do is open the Hue/Saturation dialog box and check the "Colorize" option and then play with the sliders.

The best way to customize the conversion from color to black and white in Photoshop is via a control called Channel Mixer (this is not available in basic image-editing programs). When you open Channel Mixer Adjustment Layer you can make the black and white image any contrast and brightness level you desire.

The Channel Mixer has four sliders and a check box. To begin, check the Monochrome box. Then work the sliders up and down, using Red and Blue for contrast and Green for luminance, or brightness. As you work the sliders you'll see the many variations you can create. The result is an RGB file with a customized look and feel that can match any effect you desire.

Toning is one way to add variety to monochrome images. I scanned this photograph of leaves in a frozen pond from a black and white negative using RGB mode then used a Hue/Saturation Adjustment Layer to add color. These variations are just two from the hundreds of image color possibilities.

Sharpness (Unsharp Masking)

If an image seems to lack "snap" or seems "soft" around its tonal edges, all you might need to do is add some sharpening. In computer-speak, sharpening is called "unsharp masking," which means getting rid of unsharpness. This does not have anything to do with an out-of-focus picture but applies to how the edge effects of tonal borders are rendered. When you open up the Unsharp Masking dialog box (found in the Filters menu, or a similarly named place, depending on the program) you get to set the degree of sharpening and to preview the results in a box as you work.

The best way to test these controls is to play with the sliders and preview the effects. If you exceed them you'll see the image become quite harsh. My advice is to start by sharpening under 150 percent, to keep the Radius in a range of 1–4 and to keep the Threshold at 0. If you are creating a portrait you might not want to sharpen at all, or if you do to make the Threshold setting higher. And you should always sharpen right at the end of your image processing, as doing this beforehand can throw off your other controls by exaggerating their effects.

Special Effects Filters

Your image-editing program is a visual playground and there are thousands—no, millions—of permutations available. When you change one aspect of an image it can go off into an entirely different direction than when you change another. You can make very subtle changes or alter the entire feel and sense of color and contrast in a picture.

At first you will be tempted to try everything out—and you should. The freedom to do so is probably why you got into digital imaging in the first place and you should not deny yourself the pleasure of this play.

One playful area where you can spend much time is

the Filters section. Filters (or, in some programs, Special Effects), range from adding clouds to making an image look like Pop Art to creating swirling and liquefied subjects to turning into mosaics and jig-saw puzzles. You can also add Noise, smooth grain, reverse colors, covert continuous tone to a line drawing, etc.

At first blush you might think that this really makes your images look great . . . and sometimes Filters do just that. But you might also find yourself overdoing these effects and adding a cookie-cutter type of style to your images. In short, play with the Filters but don't think they are always the way to get the best from your images.

Plug-ins

Plug-ins are third-party software that add to the functionality of the host program. You might think this is adding more options than you can handle, as the host programs offer so many ways to work on an image. But these programs offer refined ways to do one thing, or to complete a multitude of tasks.

There are plug-ins for emulating the look and feel of specific black and white films, for creating graduated color blends—great for sky effects—for making water-

color and acrylic paintings from your photographs and for adding specific moods to any image. There are also plug-ins for sharpening, for making image file sizes larger for making bigger prints and for color balancing that goes beyond even what the host program may offer.

My advice is to get all you can from the host program and then start to play with plug-ins. Because they are made to handle specific tasks, they often allow you to create special effects with pushbutton ease.

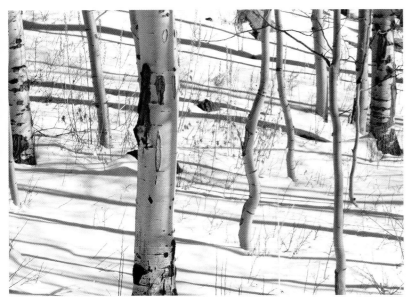

This image lent itself to a pen-and-ink rendition, so I used the Find Edges Filter in Photoshop to compress the values to just line and background was chosen. To enhance the effect even more I used the Threshold command under the Photoshop Image>Adjust menu.

Glossary

Angle of View: The maximum angle a lens covers in the field. Measured in degrees, and qualified by terms such as wide-angle, normal, and telephoto.

Aperture: The opening of a lens, the size of which is controlled by a diaphragm.

Autoexposure (AE): A method of exposure where aperture and shutter speed settings are first read, and then set, by the camera's exposure system.

Autofocus (AF) : A method of focusing where focusing distances are set automatically.

Averaging: In light metering, the situation where light is read from most of the viewfinder frame and then averaged to yield an overall, standard exposure for a scene.

Backlighting: Based on camera position, light that comes from behind the subject.

Bit: A binary digit that is the smallest piece of information used by a computer.

Bit Depth: In imaging, the number of bits used to describe pixels. The greater the bit depth the more information is described.

Brightness: The luminance of objects. The brightness of any area of the subject is dependent on how much light falls on it and how reflective it is.

Buffer: The part of the camera image processing system that is used for temporary storage of information.

Byte: A group of 8 bits, used by the computer as units of information.

CCD: Charge-coupled device; the sensor in many digital cameras.

Center-weighted Averaging Metering (CWA): In a metering scheme, an exposure system that takes most of its information from the center portion of the frame.

Chip: Common name for the digital camera's sensor, a silicon wafer with circuit paths etched or printed in layers.

Color Balance: The setting that matches the available or artificial light and faithfully renders color.

Color Temperature: Described by the Kelvin scale, which is defined in degrees and used as a standard for judging the effect a certain light source will have on color rendition.

Compression: Shrinking a file's size with the use of algorithms. Some compression schemes (called lossy) discard file information in the process. The image information is reconstructed when the file is opened again.

Contrast: The relationship between the lightest and darkest areas in a scene and/or photograph. A small difference means low contrast; a great difference, high contrast.

Depth of Field: The zone, or range of distances, within a scene that will record as sharp. Depth of field is influenced by the focal length of the lens in use, the f-stop setting on the lens, and the distance from the camera to the subject.

Digital Darkroom: Jargon for image processing programs, papers, inks and printers used to edit, manipulate and print digital images.

Digital Zoom: A setting that crops into the image and gives the illusion of using a longer focal length zoom lens.

Dodging: In digital printing and image manipulation, the selective reduction, or lightening, of tonality in certain areas of a scene.

DPI: Dots per inch. The output resolution of a printing device.

Equivalent Exposure: Recording the same amount of light, even though aperture and shutter speeds have shifted.

Exposure Compensation Control: A camera function that allows for overriding the automatic exposure reading.

Exposure Meter: Light-reading instrument that yields signals that are translated into f-stops and shutter speeds.

EV Numbers: A system of expressing exposure that combines apertures and shutter speed. EV 15 at ISO 100 might mean 1/1000 second at f/5.6, or 1/500 second at f/8.

f-stops (f-numbers): The number that designates the aperture setting, or opening. The higher the f-number, the narrower the aperture. For example, f/16 is narrower (by one stop) than f/11—it lets in half as much light.

File Format: An arrangement of digital information that may be particular to an application or generally adopted for use by a wide range of devices. Image formats in wide use include JPEG, TIFF, and GIF.

Fill Flash: "Fill-in" flash, used outdoors generally to balance the exposure of a subject that is backlit.

Filters: In computer-imaging software, a set of instructions that shapes or alters image information.

Flat: Low in contrast. Flat light shows little or no change in brightness value throughout the entire scene.

Focal Length: The distance from the lens to the film plane or sensor that focuses light at infinity.

Format: In memory cards, the type of card, such as Compact-Flash, SmartMedia, etc. In image files, the choice of JPEG, TIFF, etc.

Grayscale: The range of tones, from bright white to pitch black, that can be reproduced in a print.

Highlights: The brightest parts of a scene that yield texture or image information.

High Resolution: A relative term that defines the input and output quality of digital images (for example, sharpness, continuous tone).

Hue: Color, as defined by words such as yellow, blue, pink, etc.

Image Processor: The microprocessor in the camera that integrates image information received from the sensor with the formatting and programming done by the photographer.

Import: Bringing a file into an application; bringing image information into a working environment.

ISO: An acronym that stands for International Standards Organization, the group that standardizes, among other things,

the relative speed of sensors. ISO numbers indicate the relative light sensitivity of sensors; a higher number indicates greater light sensitivity.

JPEG: Acronym for Joint Photographic Experts Group. A type of graphics file format that is often used for compressing large image files for transmission or display.

Kelvin (K): A temperature-measuring scale used to describe the color of light. Lower temperatures describe light with a reddish or yellowish cast; higher temperatures describe light tending more toward blue or magenta.

Landscape Mode: Orienting an image so that it is wider than it is tall.

Layer: In image manipulation, an effect that is superimposed on an image that does not change the underlying pixels.

Layer Mask: A modification of a Layer that works by erasing some of the Layer to reveal the information underneath.

LCD: Liquid Crystal Display. The digital camera monitor.

LED: Light-Emitting Diode. The display on a camera's top panel that shows camera settings.

Macro: Another term for close-up photography, but specifically referring to taking pictures at or near life size.

Manual: An exposure mode in which the photographer selects aperture and shutter speeds manually and turns the lens by hand to achieve focus.

Matrix Metering: A type of metering system, also known as Evaluative or Intelligent metering, that reads various parts of the scene and then calculates exposure using a built-in microprocessor.

Maximum Aperture: The widest opening, or f-stop, a lens affords.

Memory Card and Memory Card Reader: A memory card is the common name for a PCMCIA, CompactFlash, SD, Memory Stick, xD or a similar type of card used in a digital camera. A memory card reader is a small device that patches right into the computer for easy downloading.

Microprocessor: A combination of transistors that performs specific operations. Microprocessors are found in computers and all digital cameras.

Noise: A random pattern of pixels that interferes with an image. Also called artifacts.

Overexposure: In exposure, when too much light strikes the sensor for a proper rendition of the scene.

Overrides: Making adjustments or intervening to change the camera's autoexposure system reading. Some overrides include Exposure Compensation and changing ISO ratings.

Perspective: The relationship of objects near and far, or impression of depth when a three-dimensional scene is rendered on a two-dimensional plane.

Picture Mode: A preprogrammed combination of aperture and shutter speed to match certain lighting or picture situations. Modes may include Portrait, Sports and Night Portrait.

Pixel: The picture element that forms the basis for digital imaging.

Pixel Resolution: The pixels per inch in an image, such as 640 x 480.

Plug-ins: Software that supplements image effects offered in standard image-editing and manipulation programs. Usually affords special effects and specific tasks with pushbutton ease.

Portrait Mode: Orienting an image so that it is taller than it is wide.

PPI: Pixels per inch, the basis for configuring image size, file size, and, ultimately, image quality.

Program Exposure Mode: A preset arrangement of aperture and shutter speed that is programmed into the exposure system of a camera to respond to a certain level of brightness when the camera is set at a certain ISO. Also known as Automatic.

RAM: Random access memory. The memory that stores data as an image is being worked on. For image processing, the more RAM the better.

Raw: A proprietary image file format. Raw is the image information as delivered by the sensor and is not extensively processed in the camera.

Resampling (Interpolation): When image size is changed, the process by which the computer adds data and image file size. In certain forms of resampling the computer averages adjacent pixels and adds data.

Resolution: In digital imaging, the pixel density of an image.

RGB: Red, green, blue. The channels that make up a digital image.

Saturation: In color, a vividness, or intensity.

Shutter Speed: An element of exposure; the duration of time in which light is allowed to strike the sensor.

Single Lens Reflex (SLR): A type of camera that has a movable mirror behind the lens and a ground glass for viewing the image. The sensor sits behind the mirror assembly, which swings out of the way when an exposure is made. "Single-lens" distinguishes it from rangefinder and point-and-shoot type cameras, in which the viewing angle is displaced and separate lenses are used for viewing and determining the exposure.

Speed: The duration of time in which light strikes the film.

Spot Metering: Taking an exposure reading from a very select portion of the frame.

Stop: A relative measure of light that can be used to describe an aperture or shutter speed. A difference of one stop indicates half or double the amount of light. To stop down means to narrow the aperture; to open up means to expand it.

Synchronization or Sync: The timing of the firing of the flash to coincide with the opening of the shutter so that the maximum light from that flash records on the film.

Thumbnail: A small, low-resolution version of an image. Used as a quick reference in image filing and archiving programs.

TIFF: An acronym for Tagged Image File Format. An uncompressed file format.

Tonality: The quality of light in a picture. Tones are the range of dark to light that make up the recorded image, and may or may not match the original brightness values in the scene.

White Balance: An adjustment made to compensate for the light source so that colors will render truly.

Index